Gardner's Art Through the Ages
A Global History

THIRTEENTH EDITION
Volume 1

Fred S. Kleiner
Boston University

Prepared by

Kathleen Cohen
San Jose State University

WADSWORTH
CENGAGE Learning

Australia • Brazil • Japan • Korea • Mexico • Singapore • Spain • United Kingdom • United States

ISBN-13: 978-0-495-50391-0
ISBN-10: 0-495-50391-6

Wadsworth
25 Thomson Place
Boston, MA 02210
USA

Cengage Learning is a leading provider of customized learning solutions with office locations around the globe, including Singapore, the United Kingdom, Australia, Mexico, Brazil, and Japan. Locate your local office at: **international.cengage.com/region**

Cengage Learning products are represented in Canada by Nelson Education, Ltd.

For your course and learning solutions, visit **academic.cengage.com**

Purchase any of our products at your local college store or at our preferred online store **www.ichapters.com**

Printed in Canada
1 2 3 4 5 6 7 11 10 09 08

Table of Contents

Self Quizzes

Preface

This Study Guide accompanies Volume I of *Gardner's Art through the Ages* and is intended to help you assimilate the information that you will encounter as you read the text. The Study Guide contains the following exercises which will enable you to organize and learn the material presented in your art history course:

SHORT ANSWER QUESTIONS: These questions emphasize the basic terminology of art history, important historical individuals, and mythological figures, and important concepts, places, and dates. While many of these questions are factual, others ask you to list stylistic characteristics of particular works or to write the meanings attributed to particular works and to set them within their historical contexts.

DISCUSSION QUESTIONS: Each unit ends with a variety of discussion questions that will help you assess the significance of what you have learned. Some questions are of a general, philosophical nature, requiring reference to specific artists and styles. Some ask for interpretation of theories, sometimes with reference to your daily experience. Others involve the comparison of works, artists, and styles from different times and places. These are calculated to broaden your perspective by asking you to see familiar styles in unfamiliar contexts.

SUMMARY CHARTS: Summary charts are organized chronologically and contain sections for you to fill in with names of major artistic movements or artists, typical examples, stylistic characteristics, and relevant historical information.

SELF-QUIZZES: Self-quizzes appear at the end of the study guide and each one covers multiple chapters of the text. Each quiz contains several images that you have not seen before. You are asked to attribute them to a particular artist or period and give the reasons for your attribution. Answers are given at the back, so that you can determine for yourself how well you are progressing.

If you read the text and complete the exercises in the Study Guide, by the end of the course you should be able to do the following:

1. Define and use common art historical terms.
2. Identify time periods, geographic centers, and stylistic characteristics of major art movements.
3. Identify significant religious concepts, philosophical movements, historical figures, events, and places and discuss their relationship to works of art.
4. Recognize and discuss the iconography popular during various historical periods, as well as the iconography of specific works of art.
5. Set art works in their historical context, comparing and contrasting the reasons why various cultures created works of art as well as the formal characteristics that identify them.
6. Discuss the work of major artists in terms of their artistic concerns and stylistic characteristics, the media they used, and the principal influences upon them.
7. Attribute unfamiliar works of art to particular artists, historical periods, countries, and/or styles.

Many of the questions in the guide will serve as excellent preparation for examinations. Instructors may wish to base some of their examination questions on the materials covered in the guide; they may even wish to establish with students at the beginning of the course that a specified percentage of the examination questions will be taken from the guide.

-Kathleen Cohen, Professor of Art History
San Jose State University

Tips on Becoming a Successful Student

You are starting on an art historical adventure that will enrich your lives. Some of you will do additional studies in art history, but this may be the only art history course that others of you will you take. Whichever path you chose, this course will open the past for you through objects of beauty and power created by men and women from many cultures. You will want to visit the sites of the magnificent buildings you have studied and the museums that house objects you will recognize, as well as many more that you will meet for the first time. These visits will continue to enrich your life.

 Your instructor's lectures, the textbook, and the Study Guide all reinforce each other. As you proceed with your study you will learn new study techniques that will further enhance your learning. The section below outlines a number of strategies that successful students use. Try them out and see which work best for you.

ACTIVELY LISTENING TO LECTURES:
During your professor's lectures you will have the opportunity to see large projected images of beautiful works of art, to hear when and why they were created, and to learn what they meant to the people for whom they were made. Your professor's lectures are extremely important both in learning the material and in discovering what he or she feels is most important for you to learn. Pay careful attention to the course syllabus, checking to see the order in which topics will be covered, for you will find that you get more out of the lectures if you have read the relevant material in your text book before coming to class.

It is very important to learn how to keep your mind focused on what the instructor is saying and not succumb to the warm darkness that surrounds you or to let your mind wander. Taking notes on what the lecturer is saying as well as drawing sketches of the projected art works not only imprints the material in your mind, but also helps to keep your mind focused.

You should start with a general title for the lecture and the date. Good students create a different paragraph for each work the teacher presents, headed by the artist, the title and the date. If it is a work of architecture, they include the location. On the left leave a space to draw a simple sketch. It need not be elaborate or even competent, but will serve to help you visualize the work. Then write down a few phrases that the teacher says about the significance of the work and its stylistic characteristics. You should underline the information that the teacher emphasizes.

When you look at your notes in the light, you may find that they are sloppy and hard to read, but nevertheless they are important. Rewriting them after class will further imprint the information in your mind and will provide you with material for integrating into your summary charts as you prepare for examinations. You should star the works from the lecture that also appear in the text, for you will probably want to focus your study on these works.

Sample Lecture notes:

**S Apollinare Nuovo, Ravenna. c. 504 6th c Early Byz

Theodoric patron. 3 aisle basilica form w/arcade. raised beam. wood ceiling, Mosaics above arcade & windows. Processions; prophets Christ life; beardless Christ wears purple. Flattened figures; gold background.

The abbreviations above will tell you that the teacher is most interested in you recognizing the work as Early Byzantine, done in the 6th century, that it is a basilica with an arcade (later you might look up arcade and define it if you don't know). It is decorated mosaics with processions and scenes from Christ's life. Gold backgrounds are typical and the figures are somewhat flattened. You have also noted by the two stars that the book is illustrated in the text. As you can see, the sketch is rudimentary, but it will help recall the image to your mind. (I should confess that when I was an undergraduate, my painting teacher said "If you have to paint, do, but if you can do anything else, do that!" Needless to say, I was crushed, but I think I have been a better art historian than I would have been a painter.) The point is, you don't have to be an artist to make little sketches of the works shown in class, and they will help you learn. You might want to leave a space after each image in your lecture notes to incorporate specific information from the textbook.

READING THE TEXT
The text will reinforce the instructor's lectures and provide additional background in many areas. Whenever you run across a term that you don't understand, either in the reading or the lectures, look it up in the glossary in the back of the book. You can use the glossary to check spelling and pronunciation. The textbook also includes a guide to the pronunciation of artist's names, which can be very helpful. The notes and bibliography for each chapter provide excellent resources for assembling your bibliography for a research assignment. Each chapter contains a map at the beginning and a chronology at the end. Use these as resources when you are filling out the Study Guide.

FILLING OUT THE STUDY GUIDE:

The Study Guide provides the place to write and to synthesize. Filling out the exercises in the Study Guide will contribute a great deal to your success in mastering the class material. Research has shown that the act of writing down a fact or idea rather than merely reading it serves to imprint it more securely in your mind. Furthermore, reading through the text for specific answers will help you concentrate. With the exception of the lists of definitions or identifications and the Discussion Questions at the end of each chapter, the questions follow the order of the text, so keep your study guide beside you as you read. Fill out these questions as you read though your text and use both its glossary and index to find any terms that you may have missed, as well as the terms and names found in the Definition/Identification questions.

You can use the text or sketches you made from your instructor's lectures as the basis for the sketches requested in the guide. Don't worry if your sketches are awkward; it is the idea that counts. It is also important to know that most people have better visual than verbal memories, and you are more apt to retain the image from your little sketches than from a written description. The maps are another type of visual shorthand, and they will help you put the art works in context and see which works are most closely related geographically. Use the maps in your text to locate the sites requested in the guide.

ABOUT LEARNING DATES:

Students tend to be most apprehensive about how many dates they are expected to learn in Art History classes. Some instructors put much greater emphasis on learning dates than do others. My recommendation is to learn a structure for dates–patterns–rather than trying to memorize many individual dates. The guide asks you to complete a chronology for various sections. The request to write dates in the guide is to help you organize a structure, to create a scaffolding on which you can hang events, art styles, and artists. The comparative chronologies are intended to help you to see what was going on in various parts of the world at the same time, thus creating another type of structure. We learn patterns better than isolated facts, and it becomes easier and easier to connect facts once you have established the chronological structure, the basic pattern.

You should not attempt to memorize all the dates for the various periods, but the mere act of writing them down will help you create your mental structure. For the early periods think in terms of millennia, for later materials in terms of centuries, and for recent materials you might want to think in terms of quarter centuries. Often you need to learn only a few significant dates, and then organize various materials either around that date, before or after it. You will not be too far off you know that the High Renaissance was roughly the first quarter of the 16th century, with Leonardo starting work a bit earlier and Michelangelo

continuing to work later. Sometimes a particular artistic event can help you determine the approximate date of an art work: two that come to mind are the invention of contrapposto in Greece in the early 5th century BCE and of linear perspective in Italy about 1425. Works that contain those characteristics must therefore be after the relevant date. You can often build from what you know to what you don't know if you think and ask yourself questions rather than just trying to memorize a series of dates.

THE DISCUSSION QUESTIONS:

The discussion questions at the end of each chapter are more comprehensive than the more factual questions included earlier, and they are designed to help you integrate what you have learned, make comparisons between the arts of different periods and places, and to speculate about explanations and theories. Your instructor may use them as the basis of discussion in your class, or you may discuss them with students in your study group (see Creating a study Group below). You may also use them as the basis for practice in writing essays (see below).

ESTABLISHING A STUDY GROUP:

Research has shown that students who work with others in study groups generally do better than students who work by themselves. The three elements that you will need to coordinate are 1) locating two to three students who would like to join your group, 2) finding a convenient time and 3) finding a convenient place to get together. If you live on campus in a dormitory 2 and 3 will be easier, but even if yours is essentially a commuting campus you can usually find a quiet place and a convenient time to get together in one of the classrooms that is not in use or in a corner of the student cafeteria. Some students like to get together for an hour before class each week, while others prefer to spend an evening every week or every two weeks. You instructor will probably give you a minute or two at the end of class to identify other students who might be interested in forming a group with you or groups of their own.

Activities at group meetings can vary. The discussion questions in the study guide can serve as an excellent focus for your group, with different students assigned to prepare to lead the group in discussion of specific questions each week. Each student might be responsible for preparing a specific number of image cards that can be used by the group to quiz each other.

SUMMARY CHARTS:

Among the most important aspects of the Study Guide are the Summary Charts included throughout the guide. It is here that you integrate the various things that you have learned from the lectures, your reading of the text, films you have seen, CD and Internet study and the work you have done in the guide itself. As I noted above, we remember patterns much better than individual items, and filling out the Summary Charts creates patterns in your head as well as on paper, for the activity forces you to organize and relate things to each other. Filling out the Chronology Charts as well as the map sections will help you understand how works of art relate to each other in both time and space. And actively filing in the chart is much more effective than merely reading a summary that someone else has prepared. You will probably find this method of studying so effective that you will create your own summary charts for other courses.

STUDYING FOR EXAMINATIONS:

The self-quizzes included in the Study Guide can be a great help in preparing you for course examinations as well as in letting you know how well you are progressing. The quizzes include types of questions often asked in art history examinations: matching, multiple choice, chronology exercises and attribution of unknown images. The guide itself contains other types of questions that are also commonly used: fill-ins, short answer, definitions, and essay questions. If you fill out the Study Guide as you go along, and fill out the summary sheets and take the self-quizzes included in each section before examinations, you will find that you will not need to "cram" the night before. While "cramming" can put things into short-term memory, it is not an effective way to learn. Exercises done over an extended period of time put things into your long-term memory where they have a much better chance of being retained. The best students study as they go along; they will have completed their review and might go to a movie on the night before the examination while their classmates are staying up all night trying to re-read the text and make out the scribblings in their lecture notes.

ADDITIONAL RESOURCES

The publishers of the text have prepared additional resources that will help you learn. A website for the textbook will bring you exercises, quizzes, flashcards of chapter terms with pronunciation, timelines and maps. The CD ArtStudy that came with your textbook is an excellent source which I recommend to you. The interactive the maps and the timelines are fun as well as instructive, for you get to drag and drop site names and art works into their appropriate slots. A number of the chapters have excellent sections on Architectural basics, clearly explaining the principles and giving you a drag-and-drop quiz that can test how well you have learned the principles. There are Internet activities that are linked to websites with images that you can compare, analyze, or just find out about. The On-line Quizzes are excellent and will provide important ways to study for examinations.

Some students like to look up images on the web and download them into their computer notes. An excellent source is http://worldimages.sjsu.edu which has a section devoted to Art History survey material, and you can locate images by looking up the artist or the site on the web using Google or other search tools.

CREATING YOUR OWN CHARTS ,REVIEWING IMAGES & CREATING FLASH CARDS:

You might wish to create a master sheet that includes all the images from your lectures as well as others from the text book that relate to your instructor's lectures. You could type it up or, better yet, put it on a computer so you can make additions as you run across new material you want to incorporate. If you are using a portable computer you might wish to make your class notes directly on the computer, again using abbreviations as you listen to the teacher's lecture, and then fill in additional information afterward. Bringing all of these things together as you create your charts will be a very effective way to study for examinations.

Active involvement with the images themselves by creating image flash cards is an excellent way to review the visual images. Some instructors mount slides in lighted cases while others create web sites with review images. Both of these are useful techniques. However, you can create your own image review by Xeroxing the images in the text, mounting them on 4 x 5 cards, and putting the relevant information on the opposite side. Some students have printed out thumbnail images from web sites and mounted those on their cards. You will learn a great deal just by making the cards, putting on the images, and writing the relevant information on the backs of the cards. However, you can get even more from them by shuffling them and testing yourself to see if you can give the information on the reverse when you look at the pictures. You can try sorting them by style, by chronology, or by medium. You might work with another student, selecting examples to test each other. You might even come up with some interesting card games, in which you win by having four Italian Renaissance sculptures, three Northern Renaissance paintings, and a Baroque palace, for example. Any devices that you can use to engage actively with the material will help you learn!

TAKING THE EXAM:

It is important to be calm when you take the exam. This means checking the date and time of the examination and getting there a little early so that you have a chance to relax before the exam begins. It also means being sure that you have the appropriate type of answer sheet, if one is needed, a sharpened pencil for marking it, appropriate paper for writing an essay, and a pen, as well as backups in case the pencil breaks or the pen runs out of ink. Some of these things may seem trivial, but if you are not prepared, you can be thrown off base. Before you begin, write your name clearly on all your examination materials, including the answer sheet and the various pages you used to write your essay. There is invariably one student who forgets to write his or her name on something of importance, and you don't want it to be you!

Find out if the instructor subtracts for wrong answers or just counts up correct answers. Some instructors do not want you to guess, but others don't care. I always tell students to guess rather than leaving something blank. Your wrong answer may be quite creative and cheer the instructor up. (I still recall the student who identified a Renaissance floor plan as a Mondrian painting!) Whatever you do, read the questions carefully. Also read the DIRECTIONS carefully. I always allow students to select one essay question out of three or four, but every so often there is some poor soul who tries to answer them all, and does them all badly. When you have finished the examination, check to make sure that you have correctly transferred all your answers to the mechanically scored answer sheet, if you have used one as part of your examination, and that all the blanks are filled in. Check again that your name is on everything, turn in your papers, and go home and relax.

WRITING ESSAYS:

Learning how to write clearly and succinctly is one of the most important tasks of your college career, no matter what your major. While some examination questions will be multiple choice, fill in or short answer, most exams will also include at least one essay question. Since many essay questions will either ask you to trace the development of an art form, to compare and contrast the work of two cultures or two artists, or to set particular works within their cultural contexts, the work that you do in your study guide will prepare you to answer them. The summary charts are particularly useful in this regard, for as you fill them out you do the type of summary and synthesis that serves as the basis for answers to many essay questions. Many of the discussion questions in the guide are similar to essay questions that you will find in examinations. The materials you wrote in the summary charts can be extremely useful, for you are asked to list typical examples of the work of each period or artist. Here are the examples you need for your essay. You will most likely be able to include the material you write in the stylistic characteristics column. Look carefully at the essays included

to the answers to the identifications in the self-quizzes at the end of each section of the study guide. You will see how specific examples are cited in the context of generalizations and how both stylistic features and iconography are used to provide attributions to specific cultures and/or artists. For many essays the material that you included in the significant historical people, events and ideas will be highly relevant.

You can practice writing essays by using some of the questions in the guide. First of all, read the question carefully and answer the question that is asked. This is important, for often students will go off on a tangent and not clearly deal with what they are asked. With many questions you are asked to support your generalizations by specific examples. Be sure and do so! It might be helpful to set some time limits for your practice essays so that you can get an idea of how much you will be able to write in 15 minutes or in 30. You could work with members of your study group, perhaps by all tackling the same essay. At the end of a set time you could critique each other's essays, pointing out good points and offering suggestions.

Whatever essay question that you are tackling, first jot down your ideas and then make an outline of your proposed answer, noting which specific examples you will use to support the points you are making. The outline will serve at least two purposes: 1) to organize your thinking and to help you build you essay to answer the question that you were asked, and 2) to let the reader know what points you would have made in case you run out of time. Begin your essay with an introduction noting the subject of your essay. Develop the points that you made in your outline, and then end with an appropriate conclusion. Assume that you are writing for an uninformed reader. Don't omit relevant information because you think that the teacher already knows it; your instructor is interested in what you know, so be sure and make that clear.

One last tip: Even if you are thrown by the questions, don't just walk out and leave a blank paper. Write something!! You may not gain any points, but you won't be any worse off, and you might just come up with something that is worth a point or two.

VISITING A MUSEUM AND ANALYSING A WORK OF ART:
If you are anywhere near a museum, your instructor will probably urge you to visit it and to study and write about one or more works of art you see there. No matter how good a reproduction you can find in your text or on the web, experiencing a real work of art is a different experience, and it is one that your instructor is preparing you for. The first thing that will strike you is the scale of the work; objects that appeared to be the same size in 35mm slides may be only a few inches tall while others may be over 40 feet high.

After you have walked though the collection, select the work you want to write about and look at it very very carefully. If it is a piece of sculpture walk all around it and if it is a painting or graphic go up very close to it and look at the brushstrokes or other marks. Purchase a postcard of the work or make a photograph of it if photography is permitted. There are many different ways to analyze works of art, but here is one scheme which you might want to use.

1. Write down the museum you are visiting, then the name of the work, the artist who created it, the date, the place where it was made, and the size. What technique and what materials did the artist use?

2. Write down why you selected that particular work of art. What made it attractive to you? What sort of emotional reaction did you have to the work?

3. Next describe the subject matter. What is actually represented? Is the work a portrait, a still life, a landscape? Is it a religious or mythological image? Is it telling a story? If so, what is the source of the story? Are there any symbols in the work? What do they mean? What do you think the work meant to the people who created the work?

4. Analyze the formal elements of the work using the terms that you will find later in this chapter: form and composition, line, texture, mass and volume. Study the color, describing the hues the artist used, the value, saturation and intensity of the hues, and whether the artist emphasized contrasting colors or colors that were very close to each other. Consider how the artist organized the forms the so-called design principles of balance, rhythm, proportion, etc. Is there a focal point or do the forms seem randomly placed? Do diagonal lines or verticals and horizontals dominate? Do the forms seem smooth or jagged, regular or irregular, symmetrical or asymmetrical, dynamic or static? Do the forms seem to stay on the surface or recede into the picture space? Is the space shallow or deep? Did the artist use perspective and foreshortening to create recession?

5. Last consider how effectively the artist used the materials and the formal elements to create a particular impression or to illustrate the theme of the work. How successful do you think the artist was?

TIPS ON WRITING A RESEARCH PAPER:
You may be asked to do a research paper, a paper in which you will go into greater depth about a theme or the work of a particular of a particular artist. You will be using a variety of materials written by different scholars either in journals or in books, and you will use your local library as well as on-line sources to locate these materials.

Your instructor may suggest a guide to writing about art that will explain how to go about writing the paper itself and which will explain how to avoid plagiarizing your sources. Your instructor may also have a particular form that he or she wishes you to follow in footnoting your sources and creating your bibliography. Most art historians use the form approved by the College Art Association which you can find at http://www.collegeart.org/caa/publications/AB/ABStyleGuide.html. The style guide is very thorough, covering capitalization, hyphenation and many other details, but of greatest importance for you are the sections containing the appropriate forms to use for quotations, footnotes and bibliographies.

And now it is time to begin your reading of the textbook. Scan the questions below before you start your reading, and then answer the questions and fill in the blanks as appropriate.

Introduction to Volume I

REVIEW OF THE SUBJECTS AND VOCABULARY OF ART HISTORY

Look through the textbook and select an image other than one used in the Introduction that you think represents each of the following:

Period Style:

Regional Style:

Personal Style:

TERMINOLOGY REVIEW
Use the text and the glossary or go online to find the meaning of the terms as used by art historians and define them below.

form:

composition:

medium (pl. media):

technique:

hue:

value or tonality:

intensity or saturation:

space:

mass: (The term is not in the glossary, so I will put in the definition for you). Mass defines a three-dimensional volume in space.

line: (The term is not in the glossary, so I will put in the definition for you) a series of points moving in space, as contrasted with the use of mass or shape forms. Lines may be thin or thick. A contour line defines the outer shape of an object.

Define the following terms as they apply to sculpture:

 <u>additive sculpture</u>

 <u>high relief</u>

 <u>low relief (bas-relief)</u>

 <u>subtractive sculpture</u>

Define the following terms as they apply to architecture:

 <u>elevation</u>

 <u>plan</u>

 <u>section</u>

DISCUSSION QUESTIONS

1. What factors does an art historian consider when answering the question "How old is it?" How do those factors relate to the question?

2. Why is the establishment of a correct chronological sequence important to an art historian?

3. What is the significance of context in the study of art history?

4. What is iconography and what are its functions in art history?

5. What do the two portraits of Te Pehikupe (Intro-19) tell us about the ways that artists from different cultures depict reality?

1
ART BEFORE HISTORY

TEXT PAGES 14-29

PALEOLITHIC ART

1. Define the following terms and make sure you understand what they mean in discussing Paleolithic Art.

 incise

 twisted perspective

2. Around what date are human beings thought to have *intentionally* created art works?

3. What subjects were most often depicted by Paleolithic artists?

4. What interpretations have been given to figures like the one from Hohlenstein-Stadel illustrated in FIG 1-4?

5. List three caves or caverns that contain Paleolithic paintings:

 a. b. c.

What do you think is the best explanation for why they were placed so deep in the caves?

6. Describe the organization of the bison images from Altamira FIG 1-9. Are they composed as a single composition? What viewpoint does the artist take when describing the animals?

7. The cavern of Pech-Merle contains a number of handprints, some of which are described as "negative" (FIG 1-10) others as "positive." What techniques did the artists apparently use to create these prints?

Negative prints:

Positive prints:

What are they thought to have meant?

8. Name two different techniques used at Lascaux to depict animals (FIGS. 1-11)?

 a.

 b.

What evidence could be given to support the notion that the animals at Lascaux were painted at different times?

NEOLITHIC ART

1. Identify the following terms and be sure that you know what they mean for the discussion of Neolithic art and architecture:

henge

lintel

megalith

tumulus

2. List two important Neolithic sites in the ancient Near East:

a. b.

Which site contained the earliest permanent stone fortifications?

Which site is best know for its wall paintings and shrines?

List two subjects that were portrayed in the paintings.

3. What purpose do you think the figure from Ain Ghazal (FIG. 1-15) might have served?

4. List three changes in artistic production that paralleled the shift from a food-gathering to a food-producing society.

a.

b.

c.

5. Approximately when and why was Stonehenge thought to have been erected?

Stonehenge is an early example of the post and lintel system. Draw a simple diagram of Stonehenge in the margin and point out the lintels.

DISCUSSION QUESTIONS

1. Briefly describe the differences between the so-called *Venus of Willendorf* (FIG. 1-5) and the relief of the *Woman* from Laussel (Fig. 1-6)? When comparing two figures you can begin with facts things like size, material and technique, approximate date , and what is know about where they were found. Then go on to describe the bodily features of each figure and how the similarities and differences might be interpreted.

2. Compare the bison from Tuc d'Auboubert (FIG. 1-7) and La Madeleine (FIG. 1-8) with the painted animal from Namibia (FIG. 1-3). Use the criteria described in question 1.

3. In what way did the social and economic changes that took place in human development between the Paleolithic and Neolithic periods affect the art produced in each period?

4. Compare the figure from Ain Ghazal (FIG. 1-15) with the *Venus of Willendorf* (FIG. 1-5). In what ways are they similar and how do they differ in their forms and their probable purposes? Use the approach described in question 1.

5. Describe the different structural techniques used at Newgrange (FIG.1-19) and Hagar Qim (FIG. 1-1). What is thought to have been the function of each?

LOOKING CAREFULLY, DESCRIBING AND ANALYZING

Write at least one page comparing the paintings in the Chauvet cave (FIG. 1-12) with the Deer Hunt from Çatal Höyük (FIG. 1-17). Analyze each of the images and note the major differences that you see in the handling of each of the elements. Use the following terms: form and composition; material and technique; line and color; space, mass and volume.

If you have any problems understanding what the terminology means, refer to the appropriate pages in the Introduction.

SUMMARY OF PREHISTORIC ART

Using the summary on page 29 of the text, enter the approximate dates for the following periods.

Paleolithic art: c._____ B.C.E. to c._____ B.C.E.

Neolithic art: c._____ B.C.E. to c._____ B.C.E.

Fill in as much of the chart as you can from memory. Check your answers against the text and complete the chart. Include additional material supplied by your instructor.

	Typical Examples	Stylistic Characteristics	Significant Historical Events, Ideas, etc.
Paleolithic Painting			
Paleolithic Sculpture			
Neolithic Structures			
Neolithic Painting & Sculpture			

2
THE ANCIENT NEAR EAST

TEXT PAGES 30-50

What name was given to the area between the Tigris and the Euphrates rivers?

Mesopotamia

Why was it known as the "Fertile Crescent"?

Soil is rich

SUMERIAN ART

1. Define or identify the following terms or individuals and make sure you understand what they mean in discussing Sumerian art:

city-state

Unit of government

cuneiform

Mesopotamian form of writing

cylinder seal

Used for printing

Gilgamesh

heraldic composition

hierarchy of scale

2. In what way did Sumerian city plans reflect their religious beliefs?

3. Make a simple drawing of a Sumerian ziggurat and temple in the margin.

What material did they use?

How was it oriented?

Why did they create such structures?

4. How would the female head from Uruk (FIG. 2-4) have looked when it was seen by the Sumerians?

5. The *Warka Vase* is the first known example of _____ relief sculpture (FIG. 2-5). What does it depict?

6. What underlying forms were used to create the votive statues shown on FIG. 2-6?

What is thought to have been the meaning of their hand gestures?

7. One of the figures on the *Stele of the Vultures* (FIG. 2-7) is much taller than the others. What might this indicate?

8. Look very carefully at the *Standard of Ur* (FIG. 2-8) and describe the subject: what seems to be going on. Then describe the style, for example the way the human beings and animals are represented. Examine the relative sizes of the figures, the way the bodies are turned, and the way animals are represented that are behind one another, etc.

Subject:

Style:

9. What might have been the meaning of the animals represented on the *Bull-headed Lyre* from Ur (FIG. 2-10)?

AKKAD, THE THIRD DYNASTY OF UR, & THE SECOND MILLENNIUM B.C.E.

1. Define or identify the following terms or individuals and make sure you understand their importance to the discussion of Mesopotamian art:

 citadel

 Sargon

 Gudea of Lagash

 Hammurabi

2. What new political idea was introduced by the Akkadians and how did they express it in their art?

Name an art work that illustrates it.

3. The head of the Akkadian ruler shown of Fig. 2-12 combines both naturalism and formal abstract patterning. List three features that you think are examples of each:

Naturalism Abstract patterning

a.

b.

c.

4. List two features of the *Stele of Naram- Sin* (FIG. 2-13) that indicate his super-human status.

a. b.

5. What is the significance of the *Stele of Hammurabi* (FIG. 2-17)?

Politically:

Aesthetically (be sure and note the foreshortening):

6. Who were the Hittites and what is the significance of the great Lion Gate they constructed at Boghazkoy (FIG. 2-18)?

7. List three Mesopotamian stylistic conventions found in the Elamite *Statue of Queen Napir-Asu* (FIG. 2-19)?

a.

b.

c.

ASSYRIA

1. What is a citadel?

2. One can derive a great deal from a careful analysis of a work by looking at it, even without reading about it. Look carefully at the reconstruction of the *Citadel of Sargon II* on FIG. 2-20. What does the building tell us about the Assyrians and the land in which it was built? Consider such features as its walls and fortifications, the symmetrical layout and the geometric structure.

Is it likely that this fortification was built in the mountains? Why not?

Does it look like it was built over a long period of time or under the command of a single person? Why?

What feature would in indicate that it was constructed in Mesopotamia?

3. The doorway of the citadel of Sargon II was guarded by figures known as
_____. Describe them.

Why were they portrayed with five legs?

4. What subjects were most commonly portrayed in Assyrian reliefs?

NEO-BABYLONIA AND PERSIA

1. Define or identify the following terms and make sure you understand their meaning
 and their importance to the discussion of Persian art:

 Achaemenids

 Sasanians

 iwan

 barrel vault

2. One of the seven wonders of the ancient world was created by Nebuchadnezzar.
 What was it and where was it located?

The *Ishtar Gate* built in Babylon (FIG. 2-24) was created of _____ and

 covered with _____ What motifs were used to decorate it ?

3. The great palace at Persepolis was erected to symbolize Persian imperial power. The architects created a powerful synthesis of architectural and sculptural elements using workers drawn from the cultures of :

_____, _____, and _____.

List four architectural features of the palace:
 a.

 b.

 c.

 d.

What subjects were depicted on the walls of the terrace and staircase?

4. How was the defeat of the Roman Emperor Valerian by the Sasanian ruler Shapur represented in art?

DISCUSSION QUESTIONS

1. Discuss the social and economic changes that took place in the ancient Near East that made possible the beginning of what we call civilization.

2. How did the religion practiced by Sumerians differ from that practiced by Paleolithic hunters and how were those religions reflected in art? What was the relationship between religion and the state in ancient Sumer?

3. How does the *Warka Vase* (Fig 2-4), the *Victory Stele of Naram-Sin* (FIG. 2-13), the *Stele of Hammurabi* (FIG. 2-16), and the *Assyrian Archers Pursuing their Enemies* (FIG. 2-22), and the *Ambassadors Bringing Gifts to the Persian King* ((FIG. 2-27) reflect the changing religious political ideas of the Ancient Near East? What stylistic features do the reliefs share and how do they differ?

4. How does the Elamite *Statue of Queen Napir-Asu* (FIG. 2-19) relate to the earlier Sumerian tradition of figures from Eshnunna (FIG. 2-14) and the portrait of *Gudea of Lagash* shown on FIG. 2-16? How might the media used have affected the styles? What do the first two imply about the position of women in the Ancient Near East?

5. Compare the layout and organization of the town of Çatal Höyük (FIG. 1-16) with that of the *Citadel of Sargon II* at Khorsabad (FIG. 2-20) and the palace complex at Persepolis (FIG. 2-25). What seem to have been the major concerns of the creators of each complex? What materials and building techniques were utilized by each?

LOOKING CAREFULLY, DESCRIBING AND ANALYZING

Write at least one page comparing the *Victory Stele of Naram-Sin* (FIG. 2-13) with the *Triumph of Shapur I over Valerian* (FIG. 2-28). Analyze each of the images based on the following: form and composition; material and technique; relationship of the composition to the frame; space, mass and volume, noting particularly the treatment of the bodily forms. How do the stylistic features emphasize the concept of victory? Which of the two images do you think is most effective? Why?

If you have any problems understanding what the terminology means, refer to the Introduction.

SUMMARY OF SUMERIAN & NEO-SUMERIAN ART

Using the information on page 53 of the text, enter the approximate dates for the following periods.

Sumerian art: c._____ B.C.E. to c._____ B.C.E.

Neo-Sumerian art: c._____ B.C.E. to c._____ B.C.E.

Fill in as much of the chart as you can from memory. Check your answers against the text and complete the chart. Include additional material supplied by your instructor.

	Typical Examples	Stylistic Characteristics	Historical Factors
Sumerian & Neo-Sumerian (3rd Dynasty of Ur) Architecture			Rulers & Political Structure:
Sumerian Sculpture			Principal Gods:
Sumerian Applied Art			Important Cities:
Neo-Sumerian (3rd Dynasty of Ur) Sculpture			Cultural Achievements:

SUMMARY OF AKKADIAN, BABYLONIAN AND ASSYRIAN ART

Using the information on page 53 of the text, enter the approximate dates for the following periods.

Akkadian Dynasty: c._____ B.C.E. to c._____ B.C.E.

Old Babylonian Period: c._____ B.C.E. to c._____ B.C.E.

Assyrian Empire: c._____ B.C.E. to c._____ B.C.E.

Fill in as much of the chart as you can from memory. Check your answers against the text and complete the chart. Include additional material supplied by your instructor

	Typical Examples	Stylistic Characteristics	Significant Historical Events, Ideas, etc.
Akkadian Sculpture			
Babylonian Sculpture			
Assyrian Architecture			
Assyrian Sculpture			

SUMMARY OF EGYPTIANART: MIDDLE KINGDOM TO 1ST MILLENIUM BCE

Using the information on page 79 of the text, enter the approximate dates for the following periods.

Middle Kingdom: c._____ B.C.E. to c._____ B.C.E.
New Kingdom: c._____ B.C.E. to c._____ B.C.E.
Amarna Period: c._____ B.C.E. to c._____ B.C.E.

Fill in as much of the chart as you can from memory. Check your answers against the text and complete the chart. Include additional material supplied by your instructor.

	Typical Examples	Stylistic Characteristics	Significant Historical Events, Ideas, etc.
Middle Kingdom Art			
NewKingdom Architecture			
New Kingdom Painting & Sculpture			
Amarna Period Painting & Sculpture			
1st Millennium BCE			

3
EGYPT UNDER THE PHARAOHS

TEXT PAGES 52-79

1. Briefly describe the role played by the Nile in the development of Egyptian civilization.

2. What Is hieroglyphic writing and what was the significance of the rosetta stone?

PREDYNASTIC AND EARLY DYNASTIC

1. Identify the following names and terms and find a corresponding image:

Hathor

Horus

Imhotep

Isis

ka

necropolis

Osiris

Re (or Ra)

2. The *Palette of Narmer* (FIG. 3-3), which was created about 3000 B.C, is extremely important in Egyptian history and art for several reasons. Politically, it documents:

Culturally, it records two important facts—

a. about religion:

b. about writing:

Artistically, it embodies conventions that will dominate Egyptian official art to the end of the New Kingdom, namely

a.

b.

c

3. Draw a simple digram of a mastaba and describe its function

4. Stone columns appeared for the first time in the mortuary precinct of Djoser at Saqqara. How did the shape of these columns relate to the papyrus plants that were common in Egypt?

What does it mean that they are "engaged"?

THE OLD KINGDOM

1. In what way do the pyramids of Gizeh differ from King Djoser's pyramid at Saqqara?

What is ashlar masonry and how was it used in building the pyramids at Gizeh?

2. What is thought to have been the function of the *Great Sphinx* of Gizeh?

To protect b pyramids

3. What was the primary purpose of the statue of *Khafre* (FIG. 3-12)?

What does the hawk symbolize?

List four stylistic characteristics of the statue.

a.

b.

c.

d.

4. What is meant by the "canon of human proportions", and what technique did the Egyptians use to apply it to their figures? "

Select an appropriate figure and use it to illustrate the use of the canon.

5. What features of the Seated Scribe (FIG. 3-14) would have been inappropriate for the statue of a pharaoh?

6. What subjects were commonly depicted on the walls of Egyptian tombs and what was their purpose?

THE MIDDLE KINGDOM

1. In what way does the portrait of Senusret III (FIG. 3-17) reflect the changed political conditions of the Middle Kingdom?

2. The pyramid tombs so popular in the Old Kingdom were replaced by tombs in the Middle Kingdom.

THE NEW KINGDOM AND THE FIRST MILLENNIUM B.C.E.

1. Identify the following names and terms and find a corresponding image.

Akhenaton

Amarna style

Amen-Re

Aton

Book of the Dead

Hatshepsut

Nefertiti

Ramses II

Taharqo of Kush

Tutankhamen

2. Briefly describe a typical pylon temple and make simple diagrams to illustrate it.

A. Pylon

 Brief description:

 Diagram:

B. A Hypostyle Hall (note clerestory)

 Brief description:

Diagram:

3. What was the major effect of the new Amarna style on figural representation?

4. What three features of Queen Tiye (FIG 3-32) reflect the relaxation of rules that is typical of the Amarna style?

5. Which stylistic features used in the decoration of the chest reproduced in FIG. 3-35 suggest that the chest could not have been created during the Old or Middle Kingdoms?

6. Although Ramses II lived after Akhenaton, the pillar statues that were carved for the interior of his temple (FIG. 3-23) ignore many of the stylistic features developed by the Amarna artists. Compare the figures from the *Temple of Ramses II* with the pillar statue of *Akhenaton (FIG. 3-30)*; note particularly the differences in the proportions of the figures.

Akhenaton Ramses II

What political factors might account for these differences?

DISCUSSION QUESTIONS

1. Discuss the use of convention and realism in Egyptian relief carving and painting. What types of subjects generally were treated more conventionally? Why? (Select from FIGS. 3-15, 3-16, 3-28, 3-29, 3-33, 3-35, and 3-39.)

2. In what way is the block statue of *Senusret with Princess Nefrua* (FIG. 3-27) related to the figure of Khafre FIG. 3-12) both stylistically and in terms of function?

3. Compare the portrait of Sesostris *III* (FIG. 3-17) with those of *Khafre (FIG.* 3-12) and of *Queen Nefer*titi (FIG. 3-31). What differences do you see, and how might these differences reflect changed social conditions?

4. Compare the Egyptian *Pyramid of Djoser* (FIG. 3-5, 3-6) with the *Ziggurat* at Ur (FIG. 2-15). In what ways are they similar? How do they differ? What was the function of each?

5. What do the *Great Pyramids of Gizeh* (FIGS 3-8 to 3-10) and the palace at Persepolis (FIGS. 2-25 and 2-26) say about the major concerns of the men and the societies that commissioned them?

6. Compare the rock-cut tombs at Beni Hasan (FIGS. 3-18, 3-19) with the mortuary temples of Hatshepsut (FIG. 3-20) and Ramses II (FIGS. 3-22 and 3-23). In what ways are they similar? How do they differ? In what ways do all these tombs relate to temples such as the *Temple of Amen-Re* at Karnak (FIG. 3-24)?

7. Compare the way the Egyptians depicted animals (FIGS. 3-16, and 3-28) with the way animals were depicted by the artists of ancient Mesopotamia (FIGS. 2-8, 2-9 and 2-23) and those of Paleolithic Europe (FIGS. 1-7, 1-8, 1-9 and 1-11). Which artists seem to portray them most naturally? What part does abstract pattern play in each? What role did conceptual approaches to art play in each? Which figures do you like best? Why?

8. Discuss the role that death played in Egyptian art. What relation did it have to the development of portraiture?

LOOKING CAREFULLY, DESCRIBING AND ANALYZING

Write at least one page formal analysis comparing the head of the Akkadian ruler (FIG. 2-12) with that of Tutankhamen (Fig. 3-1). What similarities and what differences do you see? Analyze each of the portraits using the following terms: form and composition; material and technique; space, mass and volume; line and color. (If you have any problems understanding what the terminology means, refer to the Introduction.)

Do you think these two heads were created for the same reason? If so, what was it? If not, how did the reasons differ?

SUMMARY OF EGYPTIAN ART: PRE-DYNASTIC TO OLD KINGDOM

Using the information on page 79 of the text, enter the approximate dates for the following periods.

Predynastic & Early Dynastic periods: c._____ B.C.E. to
c._____ B.C.E.

Old Kingdom: c._____ B.C.E. to c._____ B.C.E.

Fill in as much of the chart as you can from memory. Check your answers against the text and complete the chart. Include additional material supplied by your instructor.

	Typical Examples	Stylistic Characteristics	Significant Historical Events, Ideas, etc.
Predynastic & Early Dynastic Art			Geographic Influences:
Old Kingdom Architecture			Religious Beliefs &Gods:
Old Kingdom Sculpture			Rulers:
Old Kingdom Painting & Relief			Social Structure:

SUMMARY OF EGYPTIAN ART: MIDDLE KINGDOM TO 1ST MILLENIUM BCE

Using the information on page 79 of the text, enter the approximate dates for the following periods.
 Middle Kingdom: c._____ B.C.E. to c._____ B.C.E.
 New Kingdom: c._____ B.C.E. to c._____ B.C.E.
 Amarna Period: c._____ B.C.E. to c._____ B.C.E.

Fill in as much of the chart as you can from memory. Check your answers against the text and complete the chart. Include additional material supplied by your instructor.

	Typical Examples	Stylistic Characteristics	Significant Historical Events, Ideas, etc.
Middle Kingdom Art			
NewKingdom Architecture			
New Kingdom Painting & Sculpture			
Amarna Period Painting & Sculpture			
1st Millennium BCE			

4
THE PREHISTORIC AEGEAN

TEXT PAGES 80-97

1. Identify and briefly state the importance of each of the following for understanding the art of the ancient Agean:

Homer

Heinrich Schliemann

Arthur Evans

Linear A & Linear B

CYCLADIC ART

1. List three stylistic characteristics of the Bronze Age statuettes from the Cyclades.

a.

b.

c.

2. The authors note that Cycladic figures resemble some 20th century sculpture. If you have a copy of the text that contains the chapter on 20th century art, look through it and write down two sculptures that you think most resemble them.

a. b.

MINOAN ART

1. Identify each of the following:

 Minos

 Minotaur

 Labyrinth

2. List four characteristics of the Palace At Knossos:

 a.

 b.

 c.

 d.

3. In what way did the shape of a Minoan column differ from that of other columns? Draw a small sketch of a Minoan column.

4. In Minoan painting, human beings were most often represented in profile pose with a full-view eye, similar to conventions observed in Egypt and Mesopotamia, but they can be identified as Minoan because:

5. What is the difference between wet or true fresco and dry fresco?

6. What might explain the paintings using Minoan style and techniques that were found in Egypt?

7. Name three works of art that represent the Minoan love of nature:

 a.

 b.

 c.

8. List three characteristics of Minoan sculpture seen in the *Snake Goddess* (FIG. 4-12).

 a.

 b.

 c.

9. What is particularly significant about the depiction of human anatomy in the *Palaikastro Youth* (FIG. 4-13) and *The Harvester Vase* (FIG. 4-14)?

MYCENAEAN ART

1. Describe the structureof the following and/or draw a sketch of each.

A. Corbeled Vault

 Brief description:

 Diagram:

B. Post and Lintel

 Brief description:

 Diagram:

2. What fills the "relieving triangle" above the entrance gate to Mycenae (FIG. 4-19)?

3. Describe the technique used to create the mask shown on FIG. 4-22?

What was its function?

DISCUSSION QUESTIONS

1. Compare the styles of the Cycladic figurine of a woman (FIG. 4-1) with the Paleolithic *Venus of Willendorf* (Fig. 1-5). How are they similar and how do they differ? What do we know about their origiinal purposes?

2. In what ways does the palace at Knossos (FIGS. 4-4 to 4-6) differ from the citadel at Tiryns (FIG. 4-15), and the palace of Sargon II at Khorsabad (FIG. 2-20) and the palace of Darius a Persepolis (Fig. 2-25) What do these differnces seem to reflect about the major concerns of each civilization. What explanation can you give for the fact that the palaces at Knossos and Persepolis are not fortified?

3. What explanation can you give for the obvious difference in style between inlaid dagger blade shown in FIG. 4-23 and *The Warrior Vase* (FIG. 4-25), which were both found in Mycenaean graves?

4. Compare the depiction of animals seen in Mycenaen (FIGS. 4-1 & 4-23) with those found in Minoan art (FIGS. 4.-8, & 4-11) and in Mesopotamian examples (FIGS. 2- 23 & 2-24). Which cultures seems to be closest in spirit? Explain your answer.

5. What does "documented provenance" mean and what is its importance for works of art?

LOOKING CAREFULLY, DESCRIBING AND ANALYZING

Select a Minoan fresco and an Egyptian example and compare them. First describe the subject, then analyze each of the images using the following terms: form and composition; material and technique; space, mass and volume; line and color.

What differences do you see in the artists' approaches to composition and form, particularly in the depiction of motion and vitality? Which has the greatest sense of movement? Which elements contribute to that sense? Can you think of any reasons why this might be so?

SUMMARY OF MINOAN ART

Using the information on page 97 of the text, enter the approximate dates for the following periods.
 Old Palace period: c._____ B.C.E. to c._____ B.C.E.

 Late Minoan Art: c._____ B.C.E. to c._____ B.C.E.

Fill in as much of the chart as you can from memory. Check your answers against the text and complete the chart. Include additional material supplied by your instructor.

	Typical Examples	Stylistic Characteristics	Significant Historical Events, Ideas, etc.
Minoan Painting			
Minoan Sculpture			
Minoan Architecture			
Minoan Ceramics			
Minoan Metalwork			

SUMMARY OF CYCLADIC & MYCENAEAN ART

Using the information on page 97of the text, enter the approximate dates for the following periods.

Early Cycladic period: c._____ B.C.E. to c._____ B.C.E.

Mycenaean (Late Helladic) period: c._____ B.C.E. to c._____ B.C.E.

Fill in as much of the chart as you can from memory. Check your answers against the text and complete the chart. Include additional material supplied by your instructor.

	Typical Examples	Stylistic Characteristics	Significant Historical Events, Ideas, etc.
Cycladic Sculpture			
Mycenaean Architecture			
Mycenaean Sculpture			
Mycenaean Ceramics			

5
ANCIENT GREECE

TEXT PAGES 98-155

1. Identify the following terms:

Dorians

Ionians

Olympiad

2. Identify the role played by each of the following Greek gods and goddesses, and indicate their Roman equivalents.

Aphrodite

Apollo

Artemis

Ares

Athena

Demeter

Hera

Hermes

Poseidon

Zeus

3. Name two groups which were excluded from participation in Greek democracy:

a. b.

GEOMETRIC AND ORIENTALIZING PERIODS

1. Identify the following and describe how each was portrayed in Greek art:

centaur

sirene

2. List three characteristics typical of vase decoration from the Geometric period.
 a.

 b.

 c.

3. Why was the 7th century known as the "Orientalizing" period in Greek art?

 List two new subjects appeared on Greek vases during this time:

 a. b.

4. What effect did the establishment of a Greek trading company in Egypt in the 7th century BCE have on Greek art?

5. Name the earliest known Greek temple with sculptured decoration:
Where is it located?

6. List three characteristics of the Daedalic style:
 a.

 b.

 c.

ARCHAIC PERIOD

1. Define or identify the following:

contrapposto

foreshortening

kouros (kouroi)

kore (korai)

Exekias

Euphronius

entasis

2. What characteristics do sixth century kouros figures share with Egyptian statues?

 In what respects do they differ from them?

3. Describe the different visual effects created by the garments worn by the *Peplos Kore* (FIG. 5-11) and the *Ionian Kore* (FIG. 5-12).

4. Draw a simple floor plan of a typical Greek temple like the one that appears on page 109 and identify the following features: peristyle, naos or cella, pronaos, stylobate, column-in-antis.

Where did the people stand when worshipping at the temple?

5. List four differences between the Doric and Ionic orders.

Doric	Ionic
a.	a.
b.	b.
c.	c.
d.	d.

6. What features of the facade of the *Treasury of the Siphnians* at Delphi (FIG. 5-8) identify it as an Ionic building?

7. How does the black-figure technique of pottery decoration differ from red-figure?

Name a painter who worked in each.

Black-figure:

Red-figure:

8. Describe or draw simple diagrams of the following popular vase shapes:

A. Amphora

 Brief description:

 Diagram:

B. Krater

 Brief description:

 Diagram:

9. What features of the warrior from the west pediment of the *Temple of Aphaia* at
 Aegina (FIG. 5-28) mark it as archaic?

 What features of the warrior from the east pediment of the *Temple of Aphaia* at
 Aegina (FIG. 5-29) illustrate the new Classical mode?

EARLY AND HIGH CLASSICAL PERIODS

1. Identify the following:

 Herakles

 Lord Elgin

 Pericles

 Polygnotos

2. What mythological subject was represented on the east pediment of the *Temple of Zeus* at Olympia (FIGS. 5-31 & 5-32)?

 What is represented on the metope from Olympia (FIG. 5-33)?

3. Stand in the *contrapposto* position so you get the feel of the so-called "weight shift." Which shoulder was down? The one above your weight bearing leg or the other?

4. Briefly describe the lost wax or "hollow casting" method of casting bronze.

5. One of the most frequently copied classical statues was the *Doryphoros* (FIG. 5-40) by _____. Briefly describe his principle of *symmetria*.

6. What was the main purpose of the *Parthenon*?

 What was its basic style?

 Two Ionic elements used in it are:

 a. b.

 Like Polykleitos, the creators of the *Parthenon* believed that beauty was achieved by the use of harmonious mathematical proportions. However, the architects deviated from the strict mathematical precision. List three instances of this deviation.
 a.

 b.

 c.

 What reason did the Roman architect Vitruvius give for the deviations?

 Describe the *Athena Parthenos*:

 What do the metopes of the *Parthenon* depict, and what are they thought to symbolize?

7. What is the *Propylaia* and what architectural orders were used in it?

8. Why is the *Erechtheion* an unusual building?

 What explanations have been given for its unusual features?

9. List three stylistic features that characterize the relief of *Nike Adjusting Her Sandal* (FIG. 5-56).
 a.

 b.

 c.

10. The use of the white-ground technique was most popular on vases known as
 _____. What were the advantages of the white-ground technique over
 the black- figure or red-figure techniques?

 Were there any disadvantages?

LATE CLASSICAL PERIOD

1. What effect did the changes in Greek political and social life after the
 Peloponnesian War have on art?

2. Briefly characterize the ways in which the work of the following sculptors differed
 from the work of sculptors of the 5th century.

 <u>Praxiteles</u>

Scopas

Lysippus

3. Who was Alexander and why was he important for the study of Greek art?

4. Briefly describe the following mosaic styles and give an example of each:

pebble:

tesserae:

5. What subject is depicted in the *Alexander Mosaic* (FIGS. 5-70 & 5-1)?

List two aspects of its style that are thought to reflect Greek painting of the 4th c.
BCE.
a.

b.

6. Define the following terms as applied to Greek architecture. You may draw diagrams if you like.

skene

cavae

orchestra

tholos

7. The main advantage of a Corinthian capital over an Ionic capital was:

HELLENISTIC PERIOD

1. Define the following terms.

agora

portico

stoa

2. List four ways in which the *Temple of Apollo* at Didyma (FIG. 5-75) differs from classic Greek temple types:

a.

b.

c.

d.

3. Give an example of a city planned by Hippodomos of Miletos:
 List two of its characteristics:
 a.

 b.

4. Note four stylistic characteristics that identify the Nike of Samothrace (FIG. 5-82)
 as a Hellenistic sculpture:

 a.

 b.

 c.

 d.

5. List three works that you think best represent the realistic bent of Hellenistic
 sculptors:

 a.

 b.

 c.

6. What subject was depicted in the statue of *Laoc¨oon and his Sons* (FIG. 5-88)?

 Briefly describe its stylistic characteristics:

DISCUSSION QUESTIONS

1. How were the different conceptions of the individual in the Greek and Sumerian civilizations reflected in their art?

2. Select three vases from the following and compare them using the criteria listed below: the Minoan octopus jar (FIG. 4-11); the Greek Geometric krater from the Dipylon Cemetery (FIG. 5-2); the amphora by the Andokides Painter (FIG.5-22); the krater by the Niobid Painter (FIG. 5-59); and the lekythos by the Achilles Painter (FIG. 5-58). How does the decoration of each relate to the shape and surface of the vase, and what does the subject matter of each tell us about the people who made them?

3. Who was responsible for the creation of the Egyptian *Temple of Amen Re* (FIGS. 3-24 & 3-25) and who was responsible for the creation of the Greek *Parthenon* (FIG. 5-44)? How does the esthetic effect produced by each reflect the political and religious systems of the two cultures?

4. Discuss the development of pedimental sculpture from the point of view of narrative and formal cohesiveness as seen in the pediments of Corfu (FIGS. 5-17), Aegina (FIGS. 5-27 to 5-29) and Olympia (FIG. 5-31).

5. What are the primary changes you see in the treatment of the human figure when you compare a Greek *Kouros* (FIG. 5-8) the Egyptian figure of the pharoah (FIG. 3-13), the bronze *Warrior* from Riace (FIG. 5-35) , Praxiteles' figure of Hermes (FIG. 5-63) and Lysippos' *Apoxyomenos* (FIG. 5-65)? Note the changing proportions, the depiction of motion, and the conception of the figure in space.

6. Discuss the development of Greek relief sculpture by comparing the friezes from the *Siphnian Treasury* at Delphi (FIG. 5-19), the *Parthenon* (FIG. 5-50), and the *Altar of Zeus* from Pergamom ((FIG. 5-79). How do they embody the stylistic characteristics of the Archaic, Classic and Hellenistic styles respectively?

7. Compare the *Hellenistic Boxer* (FIG. 5-85) with representations of 5th century athletes like Myron' *Diskobolos* (FIG. 5-37) and Polykleitos'*Doryphores* (FIG. 5-40). How do they differ in emotional impact and what formal differences contribute to those effects?

8. Select three figures that you think best demonstrate the development of the female figure in Greek sculpture, one each from the Archaic, the Classic, and the Hellenistic periods. How does each illustrate the stylistic characteristics of her period?

9. How did social and political conditions of fifth century Athens differ from those of the Hellenistic period? In what ways do the figures of *Dionysos* (Herakles?) from the *Parthenon* (FIG. 5- 48) and the *Dying Gaul* (FIG. 5-81) reflect these conditions?

10. The Greeks believe that the marbles hat Lord Elgin brought to the British Museum in London should be returned to Greece, but the British disagree. Work with another student and present arguments that could be made by both sides.

LOOKING CAREFULLY, DESCRIBING AND ANALYZING

Write at least one page comparing the Battle of Issus (FIG. 5-70 & 5-1) with the relief of the Ambassadors from the Palace of Darius (FIG. 2-26). Describe what is being represented in each of the works. Analyze each of the images using the following terms: form and composition; material and technique; line and color; space, mass and volume; Perspective and Foreshortening
Note particularly how the formal elements create the sense of motion or stability, and that help to create the sense of space or lack of it.

What were the political implications of each work?

SUMMARY: THE ART OF GREECE

Identify as many of the following gods, goddesses, heroes, any mythological creatures from memory as you can. If you need help go back to the pages you already filled out in the Study Guide and/or the glossary and index in the text.

Aphrodite

Apollo

Artemis

Athena

Demeter

Dionysos

gorgons

Hera

Herakles

Hermes

Laocoon

Lapith

Medusa

Nike

Zeus

SUMMARY OF GREEK ART

Using the information on page 155 of the text, enter the approximate dates for the following periods.

Geometric& Orientalizing periods: c._____ B.C.E. to c._____ B.C.E.

Archaic period: c._____ B.C.E. to c._____ B.C.E.

Early & High Classical periods: c._____ B.C.E. to c._____ B.C.E.

Late Classical period: c._____ B.C.E. to c._____ B.C.E.

Hellenistic period: c._____ B.C.E. to c._____ B.C.E.

Fill in as much of the chart as you can from memory. Check your answers against the text and complete the chart. Include additional material supplied by your instructor.

	Political Leaders & Events	Cultural & Philosophical Figures & Ideas	Scientific Developments
Geometric & Archaic Periods			
Classical Period			
Hellenistic Period			

SUMMARY OF GREEK ARCHITECTURE

Fill in as much of the chart as you can from memory. Check your answers against the text and complete the chart. Include additional material supplied by your instructor.

	Typical Examples	Stylistic Characteristics
Orientalizing Architecture		
Archaic Architecture		
Classical Architecture		
Hellenistic Architecture		

SUMMARY OF GREEK PAINTING AND MOSAIC ART

Fill in as much of the chart as you can from memory. Check your answers against the text and complete the chart. Include additional material supplied by your instructor.

	Typical Examples	Stylistic Characteristics	Significant Historical Events, Ideas, etc.
Geometric Vase Painting			
Archaic Vase Painting & Wall Painting			
Classical Vase Painting & Wall Painting			
Classical Mosaics			

SUMMARY OF GREEK SCULPTURE

Fill in as much of the chart as you can from memory. Check your answers against the text and complete the chart. Include additional material supplied by your instructor.

	Typical Examples	Stylistic Characteristics	Artists
Geometric			
Archaic			
Early & High Classical			
Late Classical			
Hellenistic			

6
THE ART OF SOUTH AND SOUTHEAST ASIA BEFORE 1200

TEXT PAGES 156-179

INDIA AND PAKISTAN
1. List two characteristics of the Indus Valley site of Mohenjo-daro that distinguish it from contemporary sites in Mesopotamia and Egypt.
 a.

 b.

2. What is thought to have been the purpose of the Great Bath of Mohenjo-Daro?

3. What subjects ere most commonly represented on the intaglio steatite seals of Moheno-daro?

4. List three features of the figure shown in FIG. 6-5 that indicate that it may represent a prototype of the Hindu god Shiva. You may wish to refrence page 168 of your text "Hinduism and Hindu Iconography."
 a.

 b.

 c.

5. List three innovative religious ideas found in the Upanishads:
 a.

 b.

 c.

6. Briefly distinguish between three branches of Buddhism and find a work of art that is typical of each:

Therevada (Hinayana)

Mahayana

Pure Land Sects

7. What is the meaning of the following terms:

samsara

karma

nirvana (moksha)

bodhisattva

mudra

<u>Sakyamuni</u>

<u>ushnisha</u>

<u>urna</u>

8. Who was Ashoka and what was the significance of the
 inscription carved into a rock at Kalinga in present day
 Orissa? he erected throughout his kingdom?

9. List three Buddhist symbols found on the *Lion Capital*
 (FIG. 6-6):
 a.

 b.

 c.

10. Draw a simple diagram of a stupa.

 What is usually contained in a stupa?

 What does a stupa symbolize?

What is the meaning of the yasti, the pole that rises from the center of the hmarmka above the stupa?

What is circumambulation and what is its purpose for a Buddhist pilgrim?

11. The torana gates, which marked the cardinal points, include many symbolic carvings. Give the meaning of the following:

jatakas

yakshis

List two stylistic characteristics of the carving that decorates the toranas of the Great Stupa as seen in FIG. 6-8:

a.

b.

12. What is a chaitya hall?

Give two features that distinguish the chaitya hall at Karli (FIG. 6-9):
a.

b.

13. Which culture provided artistic models for the images of the *Seated Buddha* and the frieze from Gandhara (FIGS. 6-10 & 6-11)?

14. List three stylistic characteristics of the Mathura Buddha (FIG. 6-12).

 a.

 b.

 c.

15. Look carefully at the Buddha from the Gupta period shown in Fig. 6-13 and describe how it combined the styles of Gandhara and Mathura.

16. List three characteristics of Gupta art that are apparent in the painting from Ajanta (FIG. 6-15):
 a.

 b.

 c.

17. Identify the following Hindu deities and list the forms that each can take.

 Shiva

 Vishnu

 Devi

18. What is meant by the multiple limbs and animals parts that are seen in many figures of Hindu gods?

19. What is meant by an "avatar of Vishnu"?

 Name one:

20. What is the meaning of the three faces of Shiva seen in FIG. 6-18?

21. The primary function of a Hindu temple is:

22. Identify the following parts of a Hindu temple. (You may draw and label a sketch it you like.)

 garbha griha (womb chamber)

 mandapa

 sikhara

23. What is the significance of the reliefs on the exterior of the Vishnu temple at Khajuraho (FIG. 6-24)?

24. What is the significance of bathing, feeding and clothing an image like the *Shiva Nataraja* shown on FIG. 6-25?

SOUTHEAST ASIA

1. List three characteristics of the *Death of the Buddha (Barinivana)* from Sri Lanka (FIG. 3-26) that show the influence of the Indian Gupta style:

a.

b.

c.

2. In what country is the stupa of Borobudur located?

How large is the stupa?

What do most scholars think is the intended meaning of the monument?

Name three types of objects that pilgrims would encounter as they climbed it:

a.

b.

c.

3. List three stylistic characteristics of the Early Khmer figure of *Harihara* created
 in the seventh century (FIG. 6-28).

 a.

 b.

 c.

4.Look at the aerial view of *Angkor Wat* shown on FIG. 6-30 and make a diagram
of the schematic ground plan.

5. How did Khmer rulers use art to demonstate their power and their connection
 with their personal god?

DISCUSSION QUESTIONS

1. Look at the figures in this chapter and in previous chapters. Which figures seem to be the most spiritual? What stylistic features do you think achieve this quality?

 (You could consider the figure from Mohenjo-daro (FIG. 6-1), the seated Buddha from Sarnath (FIG. 6-13), the Siva from Elephanta (FIG. 6-18), the face from Angkor Thom (FIG. 6-32), the yakshi from Sanchi (FIG. 6-8), the figures from the temple wall at Khajuraho (FIG. 6-24), the Goddess from Knossos (FIG. 4-12), the goddesses from the Parthenon (FIG. 5-49), the relief from the Pergamon *Altar of Zeus and Athena* (FIG. 5-79), as well as the European medieval figures of St. Martin, St. Jerome, and St. Gregory from Chartres (FIG. 18-00).

2. In what way does the function of a temple as residence of the god rather than as a hall forcongregational worship affect the style of the architecture of Hindu and Greek temples? Compare the Hindu temples in Chapter 6 with a Greek temple in Chapter 5. What function does light play in each type of building? How is sculpture used in each?

3. What Greek and Egyptian figures can you think of that share the monumental calm and sense of timelessness of the Early Khmer figure of *Harihara* (FIG. 6-28)? What stylistic features do they have in common?

4. What different metaphysical views are represented by the image of *Siva as Nataraja* (FIG. 6-26) and the *Meditating Buddha* (FIG. 6-10)?

5. Discuss the practices and iconography of Buddhism as seen in the *Great Stupa* at Sanchi (FIGS. 6-7 to 6-8) and in the monument of Borobudur in Java (FIG. 6-27).

LOOKING CAREFULLY, DESCRIBING AND ANALYZING

Write at least one page comparing the detail of the Yakshi and elephant from Sanchi (FIG. 6-7) with contemporary figure of Aphrodite and Pan (FIG. 5-84). First describe the subject matter and iconographic meaning of each images, and then analyze them using the following terms: form and composition; material and technique; line and color; space, mass and volume.

Note particularly the handling of the nude and the formal relationship of the nude to auxiliary figures. What sort of balance does each figure have and how did the artist create it?

Write at least one page comparing the detail of the yakshi from the *Great Stupa* at Sanchi (FIG. 6-8) with roughly contemporary figure of *Nike of Samothrace* (FIG. 5-82). First describe the subject matter and iconographic meaning of each image, and then analyze them using the following terms: form and composition; material and technique; line and color; space, mass and volume.

Note particularly the handling of the figure and its formal relationship to its setting. How does each figure relate to nature?

SUMMARY OF INDIA, PAKISTAN AND SOUTH EAST ASIA

Using the information on page 17 of the text, enter the approximate dates for the following periods.

Indus Valley Civilization: c._____ B.C.E. to c._____ B.C.E.

Maurya Dynasty: c._____ B.C.E. to c._____ B.C.E.

Shunga, Andhra & Kushan Dynasties: c._____ B.C.E. to c._____ C.E.

Gupta & Post-Gupta Periods: c._____ C.E. to c._____ C.E.

Medieval Period: c._____ C.E. to c._____ C.E.

Fill in as much of the chart as you can from memory. Check your answers against the text and complete the chart. Include additional material supplied by your instructor.

	Typical Examples	Stylistic Characteristics	Significant Historical Events, Ideas, etc.
Indus Valley Civilization			
Maurya (Asoka) Dynasty			
Shunga Andhara & Kushan Dynasties			
Gandhara Sculpture			
Mathura Sculpture			

SUMMARY OF INDIA, PAKISTAN AND SOUTH EAST ASIA continued

Fill in as much of the chart as you can from memory. Check your answers against the text and complete the chart. Include additional material supplied by your instructor.

	Typical Examples	Stylistic Characteristics	Significant Historical Events, Ideas, etc.
Buddhist Architecture			
Hindu Architecture			
Buddhist Sculpture			
Hindu Sculpture			
Sri Lanka Sculpture			
Java (Indonesia) Architecture			
Khmer (Cambodia) Art			

7
THE ART OF EARLY CHINA AND KOREA TO 1279

TEXT PAGES 180-205

CHINA

1. Where was the prehistoric Yangshao culture located?

 What was its major artistic form?

2. What is the difference between earthenware and stoneware?

3. List six types of objects found in tombs of Shang rulers and those of Sanxingdui and note the material from which they were made.

 a. b.

 c. d.

 e. f.

4. Briefly identify the following:

 <u>Confucianism</u>

 <u>Daoism</u>

 <u>yin and yang</u>

5. What did dragons symbolize for the Chinese?

6. What was found in excavations around the tomb mound of the first Emperor of Qin, Shi Huangdi, at Lintong?

7. What were the primary sources of the subject matter of the art of the Han dynasty?
 a. b.

List three stylistic characteristics of Han reliefs as seen in FIG. 7-8.
a.

b.

c.

8. What was the Silk Road and what effect did it have on Chinese culture and art?

9. List four formats used by Chinese painters:
 a. b.

 c. d.

What format was used for *Lady Feng and the Bear* (FIG. 7-12).

List three adjectives that describe its style:
a.

b.

c.

10. Describe three stylistic features, derived from Gandharan prototypes, that occur in the earliest Chinese image of the Buddha (FIGS. 7-11).

a.

b.

c.

In what ways does the figure of Vairocana Buddha at Longmen (FIG. 7-14)) differ from it?

a.

b.

c.

11. What features distinguish traditional Chinese architecture from that of Egypt and Greece?

Describe the method of construction:

What materials did they commonly use?

What colors were favored?

What type of roof line was favored?

12. Define the following terms as used in Chinese architecture:

<u>clustered brackets</u>

<u>bays</u>

13. What sect of Buddhism was illustrated in the painting of the *Paradise of Amitaba* shown on FIG. 7-15?

What features make you think so?

14. List three stylistic characteristics of the Tang painting style that can be seen in the detail from *The Thirteen Emperors* shown on FIG. 7-17.
 a.

 b.

 c.

15. List two devices that were used in the Tang painting *Palace Ladies* (FIG 7-18) to give a sense of depth and space to the composition.

 a.

 b.

16. List four types of figurines commonly found in Tang tombs:

 a. b.

 c. d.

17. Describe three stylistic characteristic of Fan Kuan's *Travelers among Mountains and Streams* (FIG. 7-20):
 a.

 b.

 c.

18. What influence did calligraphy have on Chinese painting?

19. What is a pagoda, and from what form did the Chinese pagoda develop?

20. List three elements that are typical of Southern Song landscape painting:

 a.

 b.

 c.

21. How did the beliefs of the Chan (Japanese Zen) sect of Buddhism influence art?

22. List the dynasty in which each of the following painters worked:

 Ma Yuan:

 Liang Kai:

 Zhou Jichang:

Which was most influenced by the philosophy of Chan Buddhism?

KOREA

1. What role did Korea play vis-à-vis the cultural interchange between China and Japan?

2. What religion dominated Korean art during the Silla and Koryo periods?

3. How does the structure of Korean Buddhist monument at Sokkuram (FIG. 7-28) differ from the Chinese monument at Longmen (FIG. 7-14)?

 Compare the features of the Korean Buddha (FIG. 7-28)with others from chapters 6 and 7 and say which it most resembles. Why?

4. What is celadon?

 Where and when was it invented?

DISCUSSION QUESTIONS

1. Compare a bronze kuang from the Shang period (FIG. 7-3) with the Paleolithic *Bison* (Fig. 1-8) and the Minoan vase (FIG 4-11). How does each artist relate the form of the vessel to the form of the animal? Can you think of another period in Western art when animal patterns were closer to those expressed in the Chinese bronze?

2. Compare a Han relief (FIG. 7-8) with a Sumerian seal (FIG. 2-11). In each case consider the type of line used, the relationship of the figures to the space, and the formal conventions used for depicting the figures.

3. Discuss the influence of the philosophies of Confucianism and Daoism on Chinese painting. Find an image that best illustrates the ideals of each and explain why it does so.

4. What is the major difference between Chinese and Western attitudes toward nature? How have these attitudes been reflected in art? Select specific works to illustrate your discussion.

5. The following figures were created within approximately 200 years of each other: the *Standing Male Figure* from Sanxingdui shown in FIG. 7-4, the Minoan *Snake Goddess* in FIG. 4-12 , the *Statue of Queen Napir-Asu* from Susa (FIG. 2-19), and the *Pillar Statue of Akhenaton* (FIG. 3-30). Discuss the material, the scale, and the emotional effect as well as the possible purpose of each.

6. Select two representations of the Buddha, one Chinese, one Indian. How do they differ in the treatment of the figure and the drapery?

LOOKING CAREFULLY AND ANALYSING

Look carefully at Fan Kuan's painting that is reproduced on FIG. 7-1 and describe it as fully as you can. The following questions can help you, but should not limit your observations. First describe the materials and the painting techniques that are used by the artist. Are the colors opaque, tranparent? Are they bright, subtle? Highly contrasting? Then describe the shape of the mountains. How does the shape of the upper mountains differ from that of the lower mountains? Next describe the shapes of the trees. Which are covered with leaves, which are not? How do their shapes differ? What forms does the water take? Describe the scale and the relationship of the various shapes to each other. Which forms come forward, which receed? What devices are used by the artist to create the sense of space? Can you find the human beings? How does their relationship to the mountains affect the mood of the picture? What philosophical ideas are implied by the painting.

OR

Describe how Fan Kuan's painting illustrates Xie He's *Six Canons* (of painting) that are listed on page 191.

SUMMARY OF CHINESE ART

Using the information on page 205 of the text, enter the approximate dates for the following periods.

Shang Dynasty: _____ B.C.E. to _____ B.C.E.

Zhou & Qin Dynasties: _____ B.C.E. to _____ B.C.E.

Han & Period of Disunity: _____ B.C.E. to _____ C.E.

Tang Dynasty: _____ to _____

Song Dynasties: _____ to _____

Fill in as much of the chart as you can from memory. Check your answers against the text and complete the chart. Include additional material supplied by your instructor.

	Typical Examples	Stylistic Characteristics	Significant Historical Events, Ideas, etc.
Neolithic			
Shang			
Zhou & Qin			
Han			
Tang			
Song			

SUMMARY OF KOREAN ART

Using the information on pages 202 & 204 of the text, enter the approximate dates for the following periods.

Three Kingdoms Period: _____ B.C.E. to _____ B.C.E.

Unified Silla Kingdom: _____ B.C.E. to _____ B.C.E.

Koryo: _____ B.C.E. to _____ C.E.

Fill in as much of the chart as you can from memory. Check your answers against the text and complete the chart. Include additional material supplied by your instructor.

	Typical Examples	Stylistic Characteristics	Significant Historical Events, Ideas, etc.
Three Kingdoms			
Unified Silla			
Koryo			

8
JAPAN BEFORE 1333

TEXT PAGES 206-221

1. What was the main art form of the Jomon culture?

How do Jamon vessels differ from Neolithic Chinese examples?

2. Name the two cultures that had the strongest influence on the development of Japanese art.

 a. b.

3. What was the purpose of the great tumuli that were built during the Kofun period?

What are *haniwa* and how did they relate to these structures?

4. Name the largest and most important Shinto shrine in Japan.

What Japanese custom assures us that the present building looks pretty much like the first and original one?

5. Identify the following:

 <u>Amaterasu</u>

 <u>kami</u>

 <u>mortise-and-tenon</u>

 <u>ridge pole</u>

 <u>Shinto</u>

6. In what century was Buddhism established in Japan?

7. What culture provided the mold for the Horyu-ji and Todai-ji temples complexes?

8. Identify the following terms:

 <u>Amida</u>

 <u>Buddha triad</u>

Mandorla

Torii Busshi

9. Describe the type of image that was introduced during the Heian period that reflected the influence of Esoteric Buddhism.

10. What type of birds are perched on the ends of the ridge poles of the *Phoenix Hall* shown in FIG. 8-13 and what is their meaning?

11. What is the *Tale of Genji*?

Who wrote it? When?

List three characteristics of the Yamato-e style seen in the Genji scrolls (FIG. 8-14).

a.

b.

c.

DISCUSSION QUESTIONS

1. Compare the architectural style and building techniques of the *Kondo* (*Golden Hall*) of Horyuji (FIG. 8-9) and the *Phoenix Hall* of the Byodoin (FIG 8-13) with those of the *Ise Shrine* (FIG. 8-6). In what way do the *Kondo* and the *Phoenix Hall* reflect Chinese prototypes?

2. Discuss briefly the interaction of native traditions and Chinese influence in the art of Japan from the fifth through the fifteenth centuries. What characteristics can be identified as native Japanese? What features can be considered as imported from China?

3. Discuss the evolution and spread of the figure of the Buddha by comparing the Indian Buddhas (FIGS. 6-10 and 6-12), the Chinese Sakyamuni Buddha (FIG. 7-11), the Buddha from Longmen (FIG. 7-14), the Korean Buddha from Sokkuram (FIG. 7-28), the Japanese Shaka and Yakushi Triads (FIGS. 8-7 and 8-8) . What differences if any, do you see that may be based upon nationality? What are based upon Buddhist sect? Were the Japanese figures made for Hinyana or Mahayana Buddhists? How do you know?

4. The paintings of the Chinese *Paradise of Amitabha* (FIG. 7-13) and the Japanese *Amida Descending over the Mountain* (FIG. 8-18) are both representations made by devotees of the Pure Land sect. How did their religious beliefs differ from those of Hinyana and Mahayana Buddhists, and how were those beliefs represented in these paintings?

5. Select and compare a Chinese painting from the Song or Southern Song periods with a Japanese painting during the Kamakura period. What emotional mood is created in each and what stylistic devices does each artist use to create them?

6. Compare the portrait of *Shunjobo Chogan* (FIG. 8-16) with those of the male figure from Mohenjo-Daro (FIG. 6-1). and the Greek philosopher Demosthenes (FIG. 5-87). All three seem to have been done when the sitter was old, but the three men were depicted very differently. How do they differ, and what can you tell about their personalities from the way they were depicted? What characteristics of each helped you come to your conclusion?

LOOKING CAREFULLY, DESCRIBING AND ANALYZING

Compare the detail from the Japanese handscroll *The Legends of Mont Shigi* (FIG. 8-15) with the contemporary Chinese hanging scroll of *Arhats Giving Alms to Beggars* (FIG. 7-26.) How does the format of each affect the composition? Use the following terms in your analysis: mass and line, definition of 2 and 3 dimensional space, use of perspective, hue, tonality, and saturation of color, movement and balance.

SUMMARY OF JAPANESE ART

Using the information on page 221 of the text, enter the approximate dates for the following periods.

Jamon & Yayoi Periods: c._____ B.C.E. to c._____ C.E.

Kofun Period: _____ to _____

Asuka & Nara Periods: _____ to _____

Heien Period: _____ to _____

Kamakura Period: _____ to _____

Fill in as much of the chart as you can from memory. Check your answers against the text and complete the chart. Include additional material supplied by your instructor.

	Typical Examples	Stylistic Characteristics	Significant Historical Events, Ideas, etc.
Jomon & Yayoi			
Kufan			
Asuka & Nara			
Heian			
Kamakura			

9
THE ETRUSCANS

TEXT PAGES 222-235

EARLY ETRUSCAN ART

1. Define the following terms:

fibula

granulation

necropolis

tumulus (tumuli)

acroterion

2. Name four important Etruscan settlements.
 a. c.

 b. d.

3. List four architectural characteristics of Etruscan temples that distinguish them from Greek temples.
 Etruscan temple Greek temple
 a. a.

 b. b.

 c. c.

 d. d.

4. List three stylistic characteristics of the *Apula (Apollo)* from Veii (FIG. 9-4) that distinguish it as Etruscan.

a.

b.

c.

Where was it originally placed?

5. What were the favorite materials of Etruscan sculptors?

a. b.

LATER ETRUSCAN ART

1. Define the following terms and understand what they mean for understanding Etruscan art:

chimera

cista

voussoir

arcuated gateway

2. Why is the Etruscan *Capitoline Wolf* (FIG. 9-11) so famous?

3. Describe the medium and technique used for decorating *The Ficoroni Cista* (FIG. 9-13).

4. In what way is the *Sarcophagus of Lars Pulena* (FIG. 9-15) different from that of the reclining couple shown in FIG 9-5?

How might the subject on the reliefs relate to the political situation of the Etruscans in the 2nd c BCE?

5. List two features of the magnificent bronze figure of *Aule Matele* (FIG. 9-16) that show the influence of the Romans.

a.

b.

DISCUSSION QUESTIONS

1. Compare the *Apulu (Apollo)* from Veii (FIG. 9-4) with the *Riace Warrior* (FIG. 5-35). Explain how the typical Etruscan features of the former contrast with the typical Greek features of the latter.

2. How do the style, color, subject matter, and mood of an Etruscan fresco (FIG. 9-1) compare with those of a contemporary Greek vase painting (FIG. 5-60)?

3. In what way was the Etruscan rise and fall from power reflected in the decoration of their tombs? To what degree was it reflected in their bronze work?

4. Compare the Etruscan sarcophagus with the reclining couple on FIG. 9-5 with the Egyptian funerary monument from Gizeh shown on 3-13 and the Greek funerary stelea on 5-57 and 5-64. What do these monuments say about relationships between people and between the sexes in these societies as well as about their ideas toward death?

5. Do you think that Etruscan landscape paintings like the one on FIG. 9-10 are closer to Egyptian or Minoan paintings? Why?

6. What do art images tell us about the relative positions of Greek and Etruscan women? Select two examples from each culture to illustrate your argument.

LOOKING CAREFULLY AND ANALYZING

Describe the function of a fibula and then compare the Etruscan fibula on FIG. 9-1 with the Frankish fibula on Fig. 16-0). Look very carefully at the two fibula and describe what you see. How do their shapes differ and how do the shapes relate to their function? What size are they? What materials and what techniques are used for each? Carefully describe the decorative forms and patterns used on each piece. How do they differ? How do the decorative forms relate to the underlying shapes? Try to imagine a fibula of each size on your shoulder and imagine in what circumstances they might have been worn. Which one do you prefer? Why?

SUMMARY OF ETRUSCAN ART

Using the information on page 222-235 of the text, enter the approximate dates for the following periods.
 Orientalizing art: c._____ B.C.E. to c._____ B.C.E.
 Archaic art: c._____ B.C.E. to c._____ B.C.E.
 Classical & Hellenistic art: c._____ B.C.E. to c._____ B.C.E.

Fill in as much of the chart as you can from memory. Check your answers against the text and complete the chart. Include additional material supplied by your instructor.

	Typical Examples	Stylistic Characteristics	Significant Historical Events, Ideas, etc.
Architecture			
Painting			
Sculpture			
Applied Arts			

10
THE ROMAN EMPIRE

TEXT PAGES 236-287

REPUBLIC

1. The two cultures whose art most strongly influenced that of Rome were
 _____ and _____.

2. What two features of the *Temple of Portunus* ("*Fortuna Virilis*") (FIG, 10-3) were
 drawn from Etrurian temples?
 a.

 b.

 From Greek temples ?
 a.

 b.

 Which element is distinctly Roman?

3. List two non-Greek features of the so-called *Temple of Vesta* (FIG. 10-4)?

 a. b.

 What is the style of the temple plan?

4. What technical developments enabled the Romans to create an architecture of
 space rather than of sheer mass?

5. Define the following architectural elements and/or draw a simple illustration of each.

Barrel vault

Groin or cross vault

Pseudo-peripteral

6. What was the major function of Roman Republican portrait sculpture?

What stylistic features differentiate Roman Republican portraits from Greek examples?

Why might the *Portrait of a Roman General* (FIG 10-8) be considered "discordant."

7. In what ways does the Roman tomb relief shown on FIG. 10-6 differ from Greek examples like the one shown on FIG. 5-64. What emotional effect is created by each, and what stylistic features contribute to creating those effects?

What do funerary reliefs tell us about the position of slaves in Roman as opposed to Greek society?

POMPEII AND THE CITIES OF VESUVIUS

1. What catastrophic event has enables modern scholars to learn so much about life in a Roman town?

2. Briefly describe the following features of Pompeii, noting what went on in each venue.

 Amphitheater

 Basilica

 Capitolium

 Forum

3. Note the function of each room of a Roman villa:

 Atrium

 Cubiculum

 Fauces

 Impluvium

<u>Peristyle</u>

<u>Tablinium</u>

<u>Triclinium</u>

4. A house with the features listed above would have belonged to an upper class family. How would a dwelling for the poor differ?

5. Design a Roman house that uses at least five of the features listed above. Draw the plan and label the rooms. Use a larger paper if you like.

Where do you think the kitchen and the sanitary facilities would be found?

What type of decorations would you use in the various rooms of the house you are designing? Select from the styles illustrated above.

What features of the house would you like to have in a contemporary dwelling?

6. Briefly describe the following painting styles found in Pompeii and its vicinity and/or in Rome and note an example.

1st Style

2nd Style

3rd Style

4th Style

7. List three pictorial devices used by Roman painters to suggest depth.

a.

b.

c.

EARLY EMPIRE

1. What stylistic sources inspired the *Augustus of Primaporta* (FIG. 10-27)

What was the political message of the figure?

2. What was the purpose of the *Ara Pacis Augustae* (FIGS. 10-29 to 10-31) and how did the iconography reflect that purpose?

3. Name a building erected in France in the Augustan style:

4. What was the purpose of the *Pont-du-Gard*?

 What engineering principles was it based upon?

5. What is rustication and how was it used on the *Porta Maggiore* in Rome (FIG. 10-34?

6. Describe the hall from Nero's *Domus Aurea* that is illustrated on FIG. 10-35:

 Shape:

 Material:

 What was its major significance?

7. What name is commonly used for the Flavian Amphitheater?

 How many people could it hold?

 What material was vital for its construction?

8. How did Flavian portraits differ from those done during the Republican period?

9. The subjects depicted in the reliefs on the *Arch of Titus* were:

 a. b.

 What was their political significance?

THE HIGH EMPIRE

1. What type of plan was used at Timgad?

 Describe it:

2. What major complex did Trajan build in Rome?

 Who was its architect?

 What was portrayed on the Column of Trajan?

 Describe the technique used to create the frieze:

3. Name an emperor, other than Augustus, who commissioned art that showed
 strong Greek influence:

4. What revolutionary architectural concept finds its fullest expression in the
 Roman Pantheon (FIGS. 10-49 to10-51)?

5. Identify the following terms:

 <u>apse</u>

 <u>insula</u>

 <u>oculus</u>

6. What principle does *Hadrian's Villa* (FIG. 10-52) share with the 2nd century tomb from Petra (FIG. 10-53).

7. What types of scenes were depicted on funerary plaques found at Ostia?

8. Identify the following and give an example of each:

 apotheosis

 equestrian portrait

 encaustic painting

9. What change in burial practices caused sarcophagi to become so popular during the second century?

 What types of themes were used to decorate them?

LATE EMPIRE

1. Describe the features of the Late Antique style that are illustrated in the relief shown in FIG. 10-65:

2. What functions, other than sanitary, did Roman baths fulfill?

 What type of vaults were used for the frigidarium of the *Baths of Caracalla* (FIG. 10-67)?

3. Identify the following terms:

 caldarium

 frigidarium

 palaestra

 tepidarium

4. How do the portraits of *Trajan Decius* (FIG.10-68) and *Trebonianus Gallus* (FIG. 10-69) reflect the art of the so-called "soldier emperors"?

5. What is most distinctive about the structure of the *Temple of Venus* at Baalbek (FIG. 10-72)?

6. List three stylistic characteristics of the fourth-century portraits of the *Four Tetrarchs* (FIG. 10-73).
 a.

 b.

 c.

7. What reasons can be given for Constantine's reuse of second-century sculpture on his triumphal arch?

8. What type of vault were used to construct Constantine's *Baslica Nova* (FIG. 10-78).

What features does it share with the *Aula Palatina* (FIGS. 10-79 & 10-80) that Constantine built in Germany?

How does it differ ?

Which building most closely paralleled the structure of Early Christian basilicas?

9. What is the significance of the Christogram on Constantine's coin portrait (FIG. 10-81)?

DISCUSSION QUESTIONS

1. Discuss the influence of both Greek and Etruscan architecture on Roman temple design.

2. What different building techniques were used in the *Sanctuary of Fortuna Primigenia* (FIG. 10-5) and the *Mortuary Temple of Queen Hatshepsut* (FIG. 3-20)?. What aesthetic effects were achieved in each?

3. Select an example of Roman painting representing each of the Pompeian styles (1st, 2nd, 3rd and 4th), and explain the characteristics of each. Note the devices used to create the illusion of space.

4. Name three works commissioned by Augustus and describe their political significance.

5. How were both realistic and Greek idealizing characteristics incorporated into the *Ara Pacis Augustae* ? In what respects did the reliefs from the *Ara Pacis Augustae* (FIGS. 10-30 & 10-31) resemble the Parthenon frieze (FIG. 5-50) and how do they differ?

6. How did the Greeks and the Romans differ in their conception of architectural space? Include in you discussion the Greek *Parthenon* (FIG. 5-45), the Roman *Pantheon* (FIGS. 10-49 to10-51), the *Baths of Caracalla* (FIGS. 10-67) and the *Basilica of Constantine* (FIG. 10-78). How did the building techniques used by each determine the types of spaces that could be constructed.

7. The emperors Trajan and Hadrian both made great architectural contributions to Rome. What were they? Which do you think had the greatest effect on later architecture? Why?

8. Imagine that you were living in a domus in Pompeii and in an insula in Ostia, and describe a day you would spend in each. How do you think your days would be different?

9. Discuss the effect of changing funerary practices on Roman art. Cite specific examples.

10. Discuss the development of Roman portraiture by comparing and contrasting the heads of a Republican Roman (FIG.10-7), Augustus (FIG.10-27), Vespasian (FIG.10-37), Caracalla (FIG.10-64), Trajan Decius (FIG.10-68), and Constantine (FIG.10-77). How do the various portraits or relate to the concept of "likeness" and/or to political statements?

11. Analyze the stylistic differences between the reliefs from the Parthenon, (FIG.5-50), the *Arch of Titus* (FIGS.10-40 & 10-41, the pedestal of the *Column of Antonius Pius* (FIG.10-57 & 10-58) and the reliefs from the *Arch of Constantine* (FIG.10-76). In what ways do the style and subject matter of these reliefs reflect the social, religious, and political concerns of the society for which each was made?

12. What do the differences between *Diocletian's Palace* at Split (FIG.10-74), and *Hadrian's Villa* at Tivoli (FIG.10-52), say about changes in the political situation between the second and fourth centuries?

13. In what ways was the decline of Roman power reflected in art during the third and fourth centuries?

LOOKING CAREFULLY AND ANALYZING

Write at least a page comparing the two Roman sarcophagi shown on FIGS. 10-61 and 10-70, looking very carefully and describing what you see. First do a formal analysis using the following terms: form, composition, material, technique, space, mass and volume. Then do an iconographic analysis. How many people are shown in each scene and how are they related to each other? What is each one doing? What is each one wearing? What accessories can you find? What do all these things tell us about the people that are depicted on the two sarcophagi, and what is the meaning of each?

SUMMARY OF ROMAN ARCHITECTURE

Fill in as much of the chart as you can from memory. Check your answers against the text and complete the chart. Include additional material supplied by your instructor.

	Typical Examples	Stylistic Characteristics
Roman Republic		
Early Empire		
High Empire		
Late Empire		

SUMMARY OF ROMAN HISTORY & CULTURE

Using the information on page 286 of the text, enter the approximate dates for the following periods.

Roman Monarchy & Republic: _____ B.C.E. to _____ B.C.E.

Early Empire: _____ B.C.E. to _____ C.E.

High Empire: : _____ C.E. to _____ C.E.

Late Empire: _____ C.E. to _____ C.E.

Fill in as much of the chart as you can from memory. Check your answers against the text and complete the chart. Include additional material supplied by your instructor.

	Significant People	Political & Historical Events	Cultural Factors & Influences
Roman Republic			
Early Empire			
High Empire			
Late Empire			

SUMMARY OF ROMAN SCULPTURE

Fill in as much of the chart as you can from memory. Check your answers against the text and complete the chart. Include additional material supplied by your instructor.

	Typical Examples	Stylistic Characteristics
Roman Republic		
Early Empire		
High Empire		
Late Empire		

11
LATE ANTIQUITY

1. Identify the following:

 Torah

 orants

2. How might the images from the walls of the synagogue at Dura Europas be explained in view of the second commandment forbidding the making of graven images?

3. What were the catacombs and what was their importance for the Early Christians?

4. What did the story of Jonah symbolize for Early Christians?

5. How was Christ most often represented during the Period of Persecution?

a. b.

List three attributes he acquired during the Period of Recognition.
a. b. c.

From what source were these attributes taken?

What was their purpose?

6. What is the significance of the following themes that appear on the *Sarcophagus of Junius Bassus* (FIG. 11-7):

Christ seated between Saints Peter and Paul:

Christ on a donkey:

Adam and Eve:

Daniel and the lions:

Abraham and Isaac:

Christ before Pontius Pilate:

7. The chart of pages 296 and 297 of your text divide commonly depicted events of Christ's life and death into three categories. Place the following events in the appropriate category writing "C" for Incarnation and Childhood, "M" for Ministry, and "P" for Passion:

Adoration of the Magi	_____	Entry into Jerusalem	_____
Agony in the Garden	_____	Last Supper	_____
Annunciation	_____	Flagellation & Mocking	_____
Ascension	_____	Massacre of Innocents & Flight into Egypt	_____
Baptism	_____	Miracles	_____
Betrayal and Arrest	_____	Nativity	_____
Calling of Matthew	_____	Noli Me Tangere	_____
Cleansing of the Temple	_____	Presentation at the Temple	_____
Crucifixion	_____	Resurrection	_____
Supper at Emmaus	_____	Delivery of Keys to Peter	_____

Deposition	_____	Three Marys at the Tomb	_____
Descent into Limbo	_____	Transfiguration	_____
Dispute at the temple	_____	Visitation	_____

8. Two architectural sources for the Early Christian *Basilica of Old St. Peter's* in Rome were

a.

b.

How did Early Christian builders modify the plan of the Roman pagan basilica in order to convert it to Christian use?

9. Copy the plan of St. Peter's (FIG. 11-9) and label the following parts:
 atrium apse narthex nave transept

10. How does the church of *Santa Costanza* (FIGS. 11-11 and 11-12) differ from basilican churches?

What may have been its original purpose?

11. In what ways, other than subject matter, can Early Christian mosaics be distinguished from earlier Roman examples?

a.

b.

What qualities of the mosaic medium made it the favorite of Early Christian and Byzantine artists?

12. What Roman illusionistic elements were retained into the Early Christian mosaic *The Parting of Lot and Abraham* (FIG. 11-14)?

What new formal elements that point toward later Medieval art appear in this mosaic?

What was their purpose?

13. Identify the following:

lunette

Galla Placidia

Theodoric

Visigoths

14. Write down two remnants of Roman illusionism that can be found in the mosaic *Christ as the Good Shepherd* in the *Mausoleum of Galla Placidia* (FIG. 11-16).

a.

b.

15. The type of palace church erected in Ravenna by Theodoric (FIG. 11-17) is known as a: _____.

16. Name two features of the mosaics of the *Miracle of the Loaves and Fishes* (FIG. 11-18) that will become standard for Byzantine art:

a.

b.

17. Identify the following:

codex

diptych

illuminated manuscript

parchment

vellum

DISCUSSION QUESTIONS

1. Compare the *Basilica of Old St. Peter's* (FIGS. 11-9) with the reconstruction of the *Basilica Nova* (FIG. 10-80). What similarities and what differences do you see in the plans, elevations, and building materials used? How did the purposes of the varying parts of the two buildings differ? How was the more "spiritual" purpose of the Christian building reflected in the structure?

2. Select three images that illustrate Saint Augustine's statement that "the New Testament is hidden in the Old; the Old is clarified by the New."

3. Compare the paintings from the synagogue at Dura Europos (FIG. 11-3) with the Roman Dionysiac frieze from Boscoreale (FIG. 10-18) and the Christian mosaics from *Santa Maria Maggiori* (FIG. 11-13), the *Mausoleum of Galla Placidia* (FIG. 11-16), and *Saint Apollinare Nuovo* (FIG. 11-18). What similarities can you see in the Chrisian images to the paintings from Dura Europos and what to the Roman Dionysiac frieze. What do you think the Christians took from each style?

4. Compare the illumination from the *Vatican Virgil* (FIG. 11-19) with the Roman Dionysiac frieze from Boscoreale (FIG. 10-18) and the scene from the *Rossano Gospels* (FIG 11-21). How did all three handle perspective, illusionism, modeling with light and shade and naturalism?

5. Compare the changes in the representation of Christ and how the changes reflect the spread of Chrisitinay and its acceptance by the Romans. Select from FIGS. 11-5, 11-6, 11-8, 11-16, 11-19, and 11-22.

RESEARCHING, LOOKING CAREFULLY AND ANALYSING

Write at least a page in analysis of the *Sarcophagus of Junius Bassus* (FIG. 11-7) which contains a number of Christian scenes. First describe the architectural framework that surrounds the scenes. What types of columns and capitals do you see? How many are there? What type of entablature is used on the top row and what on the bottom? What sorts of arches are used and what type of creatures decorate the spandrels.

Next make a simple drawing of the compartments on the sarcophagus and number them.

Put corresponding numbers in a list below your drawing. On the list carefully describe the scene in the corresponding compartment. How many figures are included in each the scene? How are they arranged? What accessories are included in each scene? What seems to be going on in the scene.

See how many of the scenes you can match with the incidents from the Life of Christ that are listed on pages 296-297 as well as with the description in the text. Write the names of the scenes in the appropriate compartment on your drawing and after the appropriate number on the list. Indicate whether the scene is from the New Testament or Old Testament. Are there any scenes that are not identified? Think about the meaning off the each scene and why each might have been included. Think also about what scenes from Christ's life were not included, and see what general conclusion you can come to about the general statement made by the scenes carved on the sarcophagus.

SUMMARY OF THE ART OF LATE ANTIQUITY

Using the information on page 309 of the text, enter the approximate dates for the following.

Constantine rules: _____ to _____

Theodosius makes Christianity official religion of Roman Empire: _____

Alaric sacks Rome: _____

Fill in as much of the chart as you can from memory. Check your answers against the text and complete the chart. Include additional material supplied by your instructor.

	Typical Examples	Stylistic Characteristics	Significant Historical Events, Ideas, etc.
Synagogue Painting			
Catacombs			
Architecture			
Mosaics & Paintings			
Illuminated Manuscripts			
Luxury Arts & Sculpture			

12
BYZANTIUM

TEXT PAGES 310-339

1. What city functioned as the center for the Byzantine Empire?

2. Who in the Byzantine world was considered to be Christ's vicar on earth?

 How did this belief affect the political and religious structure of the Eastern Empire?

EARLY BYZANTNE ART

1. Give the following information about the Church of Hagia Sophia in Constantinople:

 Meaning of its name:

 Patron:

 Architects:

 Brief description of plan and structure:

 How the dome support differed from earlier domed buildings:

 Principal light source: Decoration of the dome:

2. How does a squinch differ from a pendentive? Draw sketches if you like.

3. Briefly describe the plan and structure of San Vitale at Ravenna (FIGS. 12-6 to 12-9)

4. Who were Justinian and Theodora and what is the subject of the mosaics in which they are represented in the apse of San Vitale (FIGS. 12-10 and 12-11)?

 What does Justinian's halo signify?

 What explanation is given for the curious overlapping of Justinian and Maximianus?

5. Explain the meaning of the following symbols from the apse mosaic of Sant' Apollinare in Classe (FIG. 12-12):

 Jeweled cross

 Three sheep below the cross

 Twelve sheep

 Compare the mosaic from Sant'Apolliinare with that from the mausoleum of Galla Placidia (FIG. 11-16) and describe the stylistic changes that have occurred.

6. What is the subject of the apse mosaic from the monastery of St. Catherine on Mt. Sinai (FIG. 12-13)?

List three stylistic features of the mosaic.

 a.

 b.

 c.

7. List four features that Justinian adopted from the Roman past as seen in the Barberini ivory (FIG. 12-14):

 a.

 b.

 c.

 d.

What feature makes this image Christian and not pagan?

8. In what ways does the ivory carving *St. Michael the Archangel* (FIG. 2-15) reflect Classical prototypes?

What new compositional devices are used?

What is the meaning of the lobe surmounted by the cross?

9. In what significant way does the representation of the Ascension in the *Rabbula Gospels* (FIG. 12-17) differ from biblical accounts of the event?

What might this difference say about attitudes toward Mary?

10. What was the significance of icons in Byzantine worship?

What effect did the Iconoclast controversy have on the visual arts?

MIDDLE BYZANTINE ART

1. Identify the following:

Theotokos

Pantocrator

Triptych

2. What is significant about the including of the image of the Virgin and Child in Hagia Sophia in the 9th century (FIG. 12-19)?

List two contradictory stylistic features contained in the mosaic:

a.

b.

3. List three characteristics typical of Middle Byzantine churches.

 a.

 b.

 c.

4. Describe two features that identify St. Mark's in Venice as a Byzantine building.

 a.

 b.

5. Give an example of Byzantine influence in the mosaics of the Norman Kings at Monreale (FIG. 12-25)?

 The plan of the church shows western influence. What type of plan is it?

6. Compare the image of the Virgin and Child from the Monastery of St. Catherine (FIG. 12-18) with the mosaic of Thedora from San Vitale (FIG. 12-11). What characteristics identify them both as Byzantine?

7. The range of styles during the Second Byzantine Golden Age is seen in the comparison of the mosaics of Daphne (FIG. 12-23) and the frescoes of Nerezi (FIG. 12-27). Briefly describe the style of each.

 Daphne:

 Nerezi:

8. What earlier style was revived in the so-called *Paris Psalter* (FIG. 12-28)?

List three features that illustrate this derivation:

a.

b.

c.

And one that does not:

9. Name three Byzantine characteristics that are apparent in the icon called the *Vladimir Madonna* (FIG. 12-29)?

a.

b.

c.

LATE BYZANTINE ART

1. Identify the following:

 <u>Anastasis</u>

 <u>iconostasis</u>

2. List three characteristics that differentiate late Byzantine churches from Middle
 Byzantine examples.

 a.

 b.

 c.

3. What stylistic features of the icon of *Christ as the Saviour of Souls* from Ohrid,
 Macedonia (FIG. 12-31) that link the image to the Byzantine style as seen of
 the fresco from the Katholikon at Hosios Loukas (FIG. 12-22)?

4. List three hallmarks of the style of Andrei Rublyev.

 a.

 b.

 c.

DISCUSSION QUESTIONS

1. Discuss the development of pictorial form from Roman illusionism to Byzantine pattern, noting the changes that you see in the treatment of the spacial setting and the solidity of the human body. Consider the mosaics from the Boscoreale cubiculum (FIG. 10-19), the Dionysiac frieze (FIG. 10-18), *The Parting of Lot and Abraham* (FIG. 11-13), *Christ as the Good Shepherd* (FIG. 11-16), *The Miracle of the Loaves and the Fishes* (FIG. 11-18), and the mosaic of Sant' Apollinare in Classe (FIG. 12-12).

2. The apse mosaics of San Vitale have been said to embody the Byzantine ideal of "sacred kingship." What iconographic features of the mosaics illustrate this concept?

3. Select a Byzantine mosaic or painting from the Early, Middle and Late periods. What features do they have in common that makes them Byzantine?

4. Discuss the development of Byzantine architecture considering Hagia Sophia (FIGS. 12-3 to 12-5), Hosias Loukas (FIGS. 12-20 to 12-22), and San Vitale in Ravenna (FIG. 12-6 to 12-8). In what way are these buildings related to each other and in what ways is each different?

5. Compare the scenes from the *Paris Psalter* (FIG. 12-28) and Rublev's *Old Testament Trinity* (FIG. 12-33) with the classical painting from the Ixion Room in Pompeii (FIG. 10-23). What similarities and differences do you see? Note the way space is depicted and the way the figures are modeled. What features of the Paris Psalter show the influence of classical painting?

RESEARCHING, LOOKING CAREFULLY AND ANALYSING

Write at least two pages in your analysis of the Anastasis fresco shown on FIG. 12-30. The important thing about doing an analysis like this is learning how to ask a lot of questions. First try to determine the subject matter, what is being represented, which is known as the iconography of the scene. You might look up the word "Anastasis" in the Infotrak database to find out exactly what the scene is supposed to represent and who is supposed to have been present. Then look very carefully at the figures shown in the fresco and see if you can figure out who is represented. Identify as many figures as you can. Who is in the center, and what kind of form surrounds him? Who are the figures that hold out their hands to him, and what do the positions of all three figures tell you about what is going on? What types of figures are represented in the groups on either side? What clues can their clothing and hair give you to their identify. Next describe the setting. What is on the top around the grouped figures? Then look at the lower portion of the fresco. What are the two figures coming out of? What do you see on the ground between them? What clues do all these objects give you to where the scene is taking place? What is the meaning of this particular grouping of figures? Where might the painting have been placed? What does the almond shape of the frame and the figure below it tell you about the placement? Are they representing a Buddhist, Hindu or Christian narrative? What is the symbolic meaning of the narrative?

You can learn more about the work and where it was done by doing a formal analysis of the style of the work itself. Analyze the image using the terms you learned earlier: form and composition, material and technique, line and color, space, mass and volume, perspective and foreshortening Note particularly how the formal elements create the sense of motion or stability, and that help to create the sense of space or lack of it. What does your formal analysis tell you about the style of the work? And what does the style tell you about the milieu in which it was created.

The iconographic analysis helps you understand the subject that was represented and the formal analysis helps you judge how effectively the artist represented the scene.

Your next task it to deal with the meaning of the things that you have observed about the work. Who might it have been painted for, and what do you think the scene would have meant for them?

SUMMARY OF BYZANTINE ART

Using the information on page 339 of the text, enter the approximate dates for the following periods.

Early Byzantine: _____ to _____

Iconoclasm to Restoration of Images: _____ to _____

Middle Byzantine: _____ to _____

Late Byzantine: _____ to _____

Fill in as much of the chart as you can from memory. Check your answers against the text and complete the chart. Include additional material supplied by your instructor.

	Typical Examples	Stylistic Characteristics	Significant Historical Events, Ideas, etc.
Architecture at Ravenna			
Other Early Byzantine Architecture			
Middle Byzantine Architecture			
Late Byzantine Architecture			

SUMMARY OF BYZANTNE ART Continued

	Typical Examples	Stylistic Characteristics	Significant Historical Events, Ideas, etc.
Panel & Wall Painting			
Manuscripts			
Ivories			
Mosaics at Ravenna			
Later Mosaics			

13
THE ISLAMIC WORLD

TEXT PAGES 340-363

1. List five countries conquered by Muslim soldiers in the seventh century.

 a. b. c

 d. e.

2. What important Christian city fell to the Muslims in 1453?

EARLY ISLAMIC ART

1. Identify the countries which were dominated by the following Islamic dynasties:

 <u>Abbasids</u>

 <u>Fatimids</u>

 <u>Umayyads</u>

2. Identify the fllowing terms as they relate to Islam:

 <u>caliph</u>

 <u>hejira</u>

iman

Muhammad

3. What was the relation of Islam to the patriarch Abraham?

4. Where was the *Dome of the Rock* (FIGS. 13-2 & 13-3) constructed?

 The shape was influenced by:

 How was it decorated?

5. List four features of the *Great Mosque* at Damascus that show the influence of the Greco-Roman world.
 a.

 b.

 c.

 d.

 Why are there no human or animal forms in the mosaics of the *Great Mosque* at Damascus?

6. All mosques are oriented toward the city of:

7. Identify the following architectural terms:

iwan

minaret

minbar

mirhab

quiblah wall

squinch

8. What seems to have been the purpose and function of early rural Moslem palaces?

Describe the decoration from the frieze from the *Mshatta Palace* (FIG. 13-7).

9. The *Great Mosque* of Kairouan is a typical hypostyle mosque. Draw a simple sketch of the plan from FIG. 13-8 and label the forecourt, quibla wall, mirhab, minaret, and prayer hall.

10. What is the distinguishing feature of the minaret from Samarra (FIG. 13-9)?

11. List two geometric forms that were used as the basis of the Samanid Mausoleum in Bukara (FIG. 13-10):

 a. b.

 What material was used to construct it?

12. What shapes were the arches used in the *Great Mosque* at Cordoba (FIGS. 13-11 and 13-12)?

13. Islamic ornament is characterized by

 a. b.
 c. d.

14. Identify the following:

 arabesque

 ewer

 Koran (Qur'an)

 Kufic

 Calligraphy

15. Why were textiles so highly valued in the Islamic world?

LATER ISLAMIC ART

1. Identify the following:

Muqarnas

Madrasa

Mamluks

Ottoman Turks

Sinan the Great

Suliyman the Magnificent

Shahnama

2. What is the *Alhambra* and what were its lush gardens intended to evoke?

3. How does the madrasa-mosque-mausoleum complex of Sultan Hasan in Cairo differ architecturally from a hypostyle mosque?

4. What new type of mosque was developed by the Ottoman Turks? How did it differ from the hypostyle mosques favored in other Islamic countries?

5. Describe the features of the *Great Mosque* of Isfahan that became standard for Iranian mosque design:

 The brick core of the mosque were sheathed with_____.

6. List three types of objects that were often decorated with calligraphy:

 a. b. c.

7. Give two examples of Islamic luxury items and say who they were created for and what purpose they were intended to serve.

a.

b.

DISCUSSION QUESTIONS

1. Study the reproductions of the following buildings: *Hagia Sophia* (FIGS. 12-2 to 12-4), the *Great Mosque* at Cordoba (FIG. 13-11 to 13-13), the Church of the Katholikon (FIGS. 12-20 to 12-22), and the *Pantheon* (FIGS. 10-50 and 10-51). Compare the lighting effects created by each and describe the means used to achieve such effects.

2. Compare the interplay of architectural mass and decoration found in the *Mausoleum of Sultan Hasan* (FIGS. 13-18 & 13-19) with the *Great Mosque* at Damascus (FIG. 13-5), the *Great Mosque* at Kairouan (FIG. 13-8), the *Mosque of Selim II* (FIGS.13-20 to 13-21), and the *Great Mosque* at Isfahan (FIGS. 13-22 to 13-24).

3. Compare the treatment of volume and space in the manuscript illumination from Bihzard's *Seduction of Yusuf* (FIG. 13-26) with that in the *Paris Psalter* (FIG. 12-28). In what ways does the Persian miniature differ from the Byzantine one? What factors might account for the differences?

4. Compare the treatment of the figures on the Islamic basin shown in FIG. 13-30 with the Roman horsemen shown in the Roman relief (FIG. 10-58), the Roman sarcophagus (Fig. 10-70) and Byzantine *Barberini Ivory* (FIG. 12-1). What compositional devices does each artist use, and how does each organize multiple figures and depict them? Which do you like best? Why?

5. After having read the chapter, do you feel that the essential qualities of Islamic art distinguish it from or relate it to Western art? How?

RESEARCHING, LOOKING CAREFULLY AND ANALYSING

Write at least a page analyzing the plan for The *Great Mosque* at Isfahan (FIG 13-23). Cover the photographs of the building. Analyze the floor plan and, without looking at the photographs, name and describe what the each portion of the building would look like. Be as detailed as you can be. You can check your description by looking at the photographs of the mosque as well as the plans and photographs of other mosques.

SUMMARY OF ISLAMIC ART

Using the information on page 363 of the text, enter the approximate dates for the following.

Umayyad Syria & Abbasid Iraq: _____ to _____
Islamic Spain: _____ to _____
Islamic Egypt: _____ to _____
Timurid and Safavid Iran & Central Asia: _____ to _____
Ottoman Turkey: _____ to _____

Fill in as much of the chart as you can from memory. Check your answers against the text and complete the chart. Include additional material supplied by your instructor.

	Typical Examples	Stylistic Characteristics	Significant Historical Events, Ideas, etc.
Architecture			
Architectural Decor			
Book Illustration			
Luxury arts			

14
NATIVE ARTS OF THE AMERICAS
BEFORE 1300

TEXT PAGES 364-391

MESOAMERICA

1. List the Mesoamerican cultures that were concentrated in the following regions:

 Gulf Coast

 Yucatan, Honduras, and Guatemala

 Southwest Mexico and Oaxaca

 Valley of Mexico

2. Identify the following:

 <u>Chocmool</u>

 <u>jade celt</u>

Quetzalcoatl

roof comb

stele

3. Which Mesoamerican culture is often referred to as the 'mother culture" of the region?

 What was its heartland?

 What type of architectural structure did they create at La Venta and what was its significance?

 List two types of sculpture produced by these people?

 a. b.

4. What medium was most favored by the artists of the West Mexican areas of Jalisco, Mayharit, and Colima?

 What subjects figured prominently in the art of this region?

 What quality is most characteristic of Colima figures?

5. Where was the ancient city of Teotihuacan located?

What sort of plan was used to lay it out?

What names have been given to the two largest pyramids?

a. b.

What originally stood on top of the pyramids?
6. What was found under the Temple of Quetzelcoatl at Teotihuacan and what was its significance?

7. What is the meaning of the streams of water and the human hearts that flank the Goddess depicted in FIG. 14-7?

8. List two important things that were learned about the Maya as a result of the ability to read their glyphs?

a.

b.

9. What was the ritual meaning of the ball game in Pre-Columbian life?

10. Briefly describe the structure and style of the *Temple of the Great Jaguar* at Tikal (FIG. 14-10):

11. What is thought to have been the purpose of the numerous figurines found on the island of Jaina?

12. What scenes are depicted in the Bonampak murals (FIG. 14-12)?

List four words or phrases that characterize the style of the fresco:

a. b.

c. d.

13. What does the lintel shown in FIG. 14-1 tell us about Mayan religious practices?

14. List three great cultures that declined sharply at the end of the Classic period (700-900):

a. b. c.

15. List two cultures that flourished during the Post Classic period (900-1521):

a. b.

16. Describe the form and function of the *Caracol* at Chichen Itzå:

17. What is represented on the four colossal atlantids from Tula, the capitol of the Toltecs (FIG. 14-17)?

List three characteristics of their style:

a.

b.

c.

INTERMEDIATE AREA

1. Identify the following:

El Dorado

Lost wax process

2. What was the purpose of Tairona pendants like those on FIG. 14-18?

Describe their style.

SOUTH AMERICA

1. Identify the following and make sure you understand their meaning for Pre-Columbian art:

staff god

backstrap loom

2. What sort of carving characterized Chavin sculpture like the Raimonde Stele (FIG. 14-19)

What type of figures are most typical?

3. What roles, in addition to providing ordinary clothing, did textiles play in ancient Andean life?

4. What are the *Nazca Lines* and what explanations have been given for their creation?

5. The Moche were extremely skilled potters. Many of their vessels are distinguished by the characteristic shape of the spout. Describe or draw it:

6. What is the major significance of the tomb excavated on the northwest coast of Peru in the 1980s?

7. Describe the central figure from the *Gateway of the Sun* at Tiwanaku (FIG. 14-25).

8. List two features that contrast the textiles of the Paracas and Wari:

Paracas	Wari
a.	a.
b.	b.

NORTH AMERICA

1. Identify the following:

effigy mound

gorget

2. What was the favorite material of Eskimo carvers?

List two stylistic characteristics of prehistoric Eskimo art:

a.

b.

3. What is thought to have been the purpose of most of the Adena and Mississippian art objects that have been found?

4. In what state is the Serpent Mound shown on FIG .14-29 located?

How long is the mound?

List two purposes that have been suggested for the construction of the mound:

a.

b.

5. List two characteristics of prehistoric pottery made by the Mimbres people:

a.

b.

What method was used to make this pottery?

6. What is most significant about the *Cliff Palace* at Mesa Verdi (FIG. 14-32)?

7. Describe a kiva.

What was its purpose?

DISCUSSION QUESTIONS

1. Compare the sculptural style of the *Raimondi Stele* (FIG. 14-19), the Maya stele from Copan (FIG. 14-1), the Toltec atlantids from Tula (FIG. 14-17), and the pipe from Adena (FIG. 14-28). What was the function of each type of sculpture, and how might the functions have influenced the styles of the pieces?

2. Compare the incised gorget from the Mississippian culture (FIG. 14-30) with examples of Mesoamerican art. Is it closer to the Maya style seen in FIG. 14-1 or to the Central Mexican style of Teotihuacan seen in FIG. 14-7)? In what ways? Do you think that direct influence might have been possible from one of these cultures?

3. How do the pyramids of pre-Columbian America compare in structure and function with those of Egypt and the ancient Near East.

4. What similarities can you find between the social structures of pre-Columbian America and those of Egypt and the ancient Near East? In what ways do you think the art forms of the various cultures were influenced by their social structures?

LOOKING CAREFULLY, DESCRIBING AND IMAGINING

Write at least a page the views of the Mesoamerican site of Teotihuacan (FIG. 14-5). Describe the various buildings that you see and note how they are related to each other. Look carefully at every portion of the site and see how many different buildings you can find. Imagine that you are an archeologist and come up with a theory about what sort of activities took place on the site. What sorts of ceremonies might have gone on and what parts of the site would have been involved?

SUMMARY OF NATIVE ARTS OF ANCIENT MESOAMERICA

Using the information on page 391of the text, enter the approximate dates for the following periods.

Early Horizon: c._____ B.C.E. to c._____ B.C.E.
Classic: c._____ B.C.E. to c._____ B.C.E.
Teotiuacan: c._____ B.C.E. to c._____ B.C.E.
West Mexico Shaft tombs: c._____ B.C.E. to c._____ B.C.E.
Maya: c._____ B.C.E. to c._____ B.C.E.

Fill in as much of the chart as you can from memory. Check your answers against the text and complete the chart. Include additional material supplied by your instructor.

	Typical Examples	Stylistic Characteristics	Significant Historical Events, Ideas, etc.
Olmec			
Teotihuacan			
Maya			
Colima			
Toltec			

SUMMARY OF ANCIENT SOUTH AMERICA

Using the information on page 391 of the text, enter the approximate dates for the following periods.

Early Horizon: c._____ B.C.E. to c._____ B.C.E.

Chavin: _____ to _____

Tiwanaku: _____ to _____

Wari: _____ to _____

Moche: _____ to _____

Paracas: _____ to _____

Nasca: _____ to _____

Fill in as much of the chart as you can from memory. Check your answers against the text and complete the chart. Include additional material supplied by your instructor.

	Typical Examples	Stylistic Characteristics	Significant Historical Events, Ideas, etc.
Early Horizon			
Chavin			
Tiawanaku			
Wari			
Moche			
Paracas			
Nasca			

SUMMARY OF NATIVE ARTS OF ANCIENT NORTH AMERICA

Using the information on page 391of the text, enter the approximate dates for the following periods.

Adena Culture, beginnings: _____ to _____

Earliest Eskimo/Inuit carvings: _____ to _____

Mississippian: _____ to _____

Mimbres: _____ to _____

Mesa Verde: _____ to _____

Fill in as much of the chart as you can from memory. Check your answers against the text and complete the chart. Include additional material supplied by your instructor.

	Typical Examples	Stylistic Characteristics	Significant Historical Events, Ideas, etc.
Adena			
Eskimo/Inuit			
Mississippian			
Mimbres			
Ancestral Pueblans/ Mesa Verde			

15
AFRICA

1. List three core beliefs or practices shared by many African societies that give rise to art images.

 a.

 b.

 c.

2. In what way does the fact of being nomadic or settled farmers influence the type of art a people produces?

PREHISTORIC AFRICAN ART

1. Some of the oldest art in the world were the painted animlas found in:

2. Briefly describe the rock painting from Tassili n' Aijer shown on FIG 15-2

3. Distinguish between:

 Radio carbon dating

 Thermoluminescence

4. What material did Nok sculptors use?

 List three stylistic characteristics of their sculpture:

 a.

 b.

 c.

11TH TO 18TH CENTURIES

1. List four types of objects made specifically for African leaders?
 a.

 b.

 c.

 d.

2. What technique was used to make the fly whisk shown on FIG. 15-5?

 Describe it:

3. What was the major art form of the Ife?

 Describe the style used to portray the Ife king shown on FIG. 18-9.

 Why is his head so large in proportion to his body?

4. List three types of figures that were commonly represented on the terracottas found in Djenne:

 a. b. c.

5. List two features of the Great Mosque at Djenne that wre not found in Middle Eastern mosques:

 a.

 b.

6. Many of the rock-cut buildings in Ethiopia were constructed by people who belonged to the religion of:

7. What do archaeologists believe was the function of the buildings of Great Zimbabwe?

Trade goods found in this structure indicate active trade with:

a. b. c.

What were the great soapstone birds found at Great Zimbabwe thought to have symbolized?

8. Identify the following:

Oba

Olakun

Queen Mother

9. List two stylistic characteristics of Benin art.

a.

b.

10. What is the symbolic meaning of the leopards that flank the Benin king shown on FIG. 15-13?

11. The saltcellar shown in FIG. 15-14 was the result of African artists of which group?

They worked for patrons from:

The material used was :

DISCUSSION QUESTIONS

1. Discuss the problem of chronology and dating of African art.

2. Compare the *Great Mosque* at Djenne (FIG. 15-8) with the *Beta Georghis* (Church of St. George) at Lalebela (FIG. 15-9) Describe the materials and techniques used to construct each. Which do you like best? Why?

3. What does the image of the Benin *Queen Mother* shown in FIG. 15-12 tell us about the role of women in early African societies.

4. Compare the artistic and political effect and the symbolic meanings of the costumes of the the Ife king (FIG. 15-9), the Mayan lord (FIG. 14-9), and the Egyptian pharoah (FIG. 3-13). What does the clothing that leaders wear in our society say about the way they see their role?

5. Compare the construction techniques usd at Great Zimbabwe (FIG 15-10) with those used at Mesa Verde (FIG. 14-32), at Chichen-Itza (14-14), and ancient Jericho (FIG. 1-14). What similarities and what differences do you see?

LOOKING CAREFULLY , DESCRIBING AND ANALYZING

Write at least a page comparing the Nok head on FIG. 15-2 with the head of the Queen Mother shown on FIG. 15-10. First state the materials and techniques used by the artists and then describe what you see. Compare the shape of the nose, the mouth, the lips, the eyebrows, the patterns of the hair and the scarification patterns. Then describe the decoration used on the collar and the form around the head of the Queen Mother. What forms are used to create the pattens? How have the materials affected the different forms that were created on both heads?

SUMMARY OF AFRICAN ART BEFORE 1800

Using the information on page 405 of the text, enter the approximate dates for the following:
Nok: c._____ B.C.E. to c._____ B.C.E.
Igbo-Ukwu: _____ century or _____ century
Ife: _____ to _____
Great Mosque of Djenne: _____
Lalibela: _____century
Great Zimbabwe: _____ century to _____ century
Benin: _____ century to _____ century
Sapi: _____ to _____

Fill in as much of the chart as you can from memory. Check your answers against the text and complete the chart. Include additional material supplied by your instructor.

	Typical Examples	Stylistic Characteristics	Cultural factors
Nok			
Igbo-Ukwu			
Ife			
Djenne			
Great Zimbabwe			
Lalibela			
Benin			
Sapi			

16
EARLY MEDIEVAL EUROPE

TEXT PAGES 406-429

Name three traditions which fused to create early medieval society in Western Europe:

a. b. c.

ART OF THE WARRIOR LORDS

1. Identify the following terms:

Cloisonné

fibula

Viking

2. Briefly describe the style of the decoration of the Meroviangian fibula shown of FIG. 16-2.

3. What was found at Sutton Hoo, and what was its importance?

CHRISTIAN ART: SCANDINAVIA, BRITISH ISLES, SPAIN

1. Describe the style of the decoration on the panel from Urnes (FIG. 16-5) and the animal headpost of Viking ship found near Oseberg Norway (FIG. 16-4):

2. Identify the following terms:

Hiberno-Saxon

Mozarabic

scriptorium

3. What can explain the differences in the symbols of St. Matthew seen in the *Book of Durrow* (FIG. 16-6) the *Lindesfarne Gospel* shown on FIG. 16-1.

4. List three characteristics of the style utilized on the Chi-roh-iota page from the *Book of Kells* (FIG. 16-8).

a.

b.

c.

5. What design shown on the Muiredach cross identifies it as Celtic? Draw this.

6. Who wrote the *Commentary on the Apocalypse* that is illustrated in FIG. 16-11?

CAROLINGIAN ART

1. What was the significance of Charlemagne being crowned in Rome in the year 800?

 What effect did that have on the art of Northern Europe.

2. List three ways in which the artist of the *Gospel Book of Archbishop Ebbo of Reims* (FIG. 16-14) has modified the style found in the *Gospel Book of Charlemagne* (FIG. 16-13).

 a.

 b.

 c.

 Which manuscript is most closely related to the style of the *Utrecht Psalter* (FIG. 16-15)?

 In what way?

3. Identify the following architectural terms:

 module

 monastery

 cloister

 crossing

 westwork

4. The *Palatine Chapel of Charlemagne* resembles the church of _____ in Ravenna, but is distinguished by:

 a.

 b.

5. Although the church of the *Monastery of St. Gall* is a three-aisled basilica, it differs from its Early Christian prototypes in the following ways:

 a.

 b.

 c.

 What is significance of its modular construction?

OTTONIAN ART

1. Identify the following terms:

 Bishop Bernward

 reliquary

2. List two features of the church of Saint Cyriakus in Gernrode that would be important for later medieval architecture:

 a.

 b.

3. Describe the alternate-support system or draw a diagram illustrating it:

4. The style of the figures on the bronze doors at St. Michael's at Hildesheim (FIG. 16-24) probably derives from manuscript illumination of the period. In what major way does it differ from its prototypes?

5. Name a possible source for the *Triumphal Column* in Saint Michael's at Hildesheim (FIG. 16-25):

6. List three features of the *Gero Crucifix* (FIG. 16-26) that contribute to the expression of suffering:

 a.

 b.

 c.

7. What two stylistic features seen in the *Lectionary of Henry II* (FIG. 16-28) were not apparent in earlier Carolingian illumination?

 a.

 b.

DISCUSSION QUESTIONS

1. Compare the abstract decorative art of the Early Middle Ages in Europe as seen in the ornamental page from the *Lindisfarne Gospels* (FIG. 16-1) with the Islamic decorative style as seen in the *Ardebil Carpet* (FIG. 13-28). In what ways do they resemble each other? What is distinctive about each?

2. Discuss the importance of Charlemagne's role in the history of art.

3. Compare the plan of St. Gall (FIG. 16-19), the nave of St. Cyriakus of Gernrode (FIG. 16-21), and the church of St. Michael's at Hildesheim (FIG. 16-2) to the plan of Old Saint Peters in Rome (FIG. 11-9). What similarities do you see and what changes have been made.

4. Discuss the historical and political factors represented by the image of the enthroned Otto III from his gospel book (FIG. 16-29). In what ways is this image related to the changing political and religious situation in Western Europe?

5. Discuss the treatment of space and volume in manuscript illumination, selecting pages from the *Rossano Gospels* (FIG. 11-21), the *Rabbula Gospels* (FIG. 12-17), the *Paris Psalter* (FIG 12-28), the *Book of Durrow* (FIG. 16-6), the Coronation Gospels (FIG. 16-13), the *Ebbo Gospels* (FIG. 16-14), and the *Uta Codex* (FIG. 16-27).

6. Compare crucifixion images from an Early Christian ivory (FIG. 11-22), a Byzantine mosaic at Daphni (FIG. 12-23), the Carolingian cover of the *Lindau Gospels* (FIG. 16-16), and the Ottonian *Gero Crucifix* (FIG. 16-26). How is the mood different in each of the images and how do the formal characteristics create the mood?

LOOKING CAREFULLY AND DESCRIBING

Hiberno-Saxon artists worked in complex flat patterns, but if you look very carefully you will see that the way they organized their patterns were very different. Write at least a page comparing the Carpet page from the *Lindesfarne Gospels* (FIG. 16-1) and the Chi-rho-iota page from the *Book of Kells* (FIG. 16-8). Look first at the underlying structure of each page. What large forms do you see, what symmetry and what asymmetry? What sort of a frame is used? Which forms are based on vertical and horizontal lines, which on diagonals, which on curves? Then start to look within the major forms and between them. What do you see? How are these forms composed? Are they different in the two pages? Are the mall forms the same throughout each page? Do you see small heads and feet or only abstract interlace? If you have a magnifying glass, apply it to the pages. Keep looking, closer and closer and describe what you see. Then write down the feelings you might have if you had to create such a work from the ground (or rather vellum) up.

SUMMARY OF EARLY MEDIEVAL EUROPE

Using the information on page 429 of the text, enter the approximate dates for the following periods.

Pagan warriors, Vandels and Goths:_____ to _____

Christian Scandinavia, British Isles & Spain:_____ to _____

Carolingian:_____ to _____

Ottonian:_____ to _____

Fill in as much of the chart as you can from memory. Check your answers against the text and complete the chart. Include additional material supplied by your instructor.

	Typical Examples	Stylistic Characteristics	Significant Historical Events, Ideas, etc.
Pagan warriors Merovingian Germanic			
Viking			
Hiberno-Saxon			
Visigothic Spain			

SUMMARY OF EARLY MEDIEVAL EUROPE continued

Fill in as much of the chart as you can from memory. Check your answers against the text and complete the chart. Include additional material supplied by your instructor.

	Typical Examples	Stylistic Characteristics	Significant Historical Events, Ideas, etc.
Carolingian Illumination			
Carolingian Architecture			
Ottonian Architecture			
Ottonian Sculpture			
Ottonian Illumination			

17
ROMANESQUE EUROPE

TEXT PAGES 430-459

1. What was meant by "the white robe of churches"?

2. What was the 'cult of relics'?

3. List three major pilgrimage sites favored by Medieval European pilgrims.

 a. b. c.

4. Identify the following (found throughout the chapter; if they prove difficult to find, you may want to use the index):

 Benedetto Antelami

 Bernard of Clairvaux

 Cluniac Order

 Eleanor of Aquitaine

 Giselbertus

Hildegard of Bingen

Master Hugo

Rainer of Huy

Wilgelmus

William of Normandy

FRANCE AND NORTHERN SPAIN

1. What common experience made the use of stone vaults so important to Romanesque builders?

 What advantage did stone vaults have over wooden roofs?

2. Define or identify the following architectural terms:
 Ambulatory

 barrel vault

 bay

 buttress

choir

compound pier

crossing

engaged columns

radiating chapels

transverse arch

tribune

3. Label the following parts of the plan below: ambulatory, apse, bay, buttress, crossing, nave, transept, radiating chapel, aisles, choir.

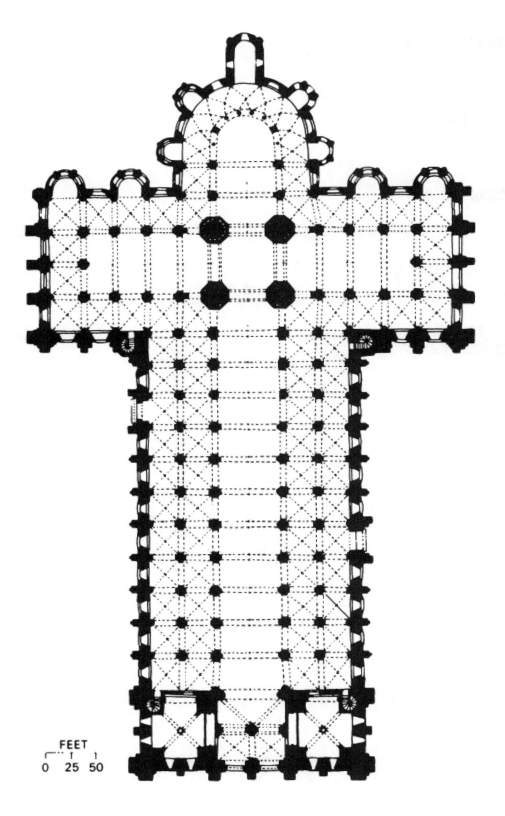

FEET

0 25 50

4. List four modifications made in Romanesque churches along the pilgrimage route to accommodate the large crowds and the relics they came to see:

 a.

 b.

 c.

 d.

5. List two features of Romanesque interiors that illustrate the modular design of the plan:

 a.

 b.

 How are the interior bays marked on the exterior?

6. A possible prototype of the stone carving of *Christ in Majesty* from Saint Sernin at Toulouse (FIG. 17-7) was:

7. Why do the authors believe that large-scale stone sculpture appeared on pilgrimage churches in the 12th century?

8. What complaint did Bernard of Clairvaux have against the creatures that decorated the columns of the Moissac cloister?

9. List four stylistic features seen in the tympanum at Moissac (FIG. 17-1):

a.

b.

c.

The subject of the tympanum is:

10. The subject of the west tympanum of Saint Lazare at Autun is:

What was the purpose of such a scene?

11. Why can it be said that the iconography of the tympanum of Vezelay was influenced by the Crusades?

12. In what way did the views of Cistercian monks affect the buildings they built? In formulating your answer compare Fonteney (FIG. 17-14) with Cluny III (FIG. 17-8).

13. What is a historiated initial?

14. What part of the church of Saint-Savin-sur-Gartempe was covered with paintings?

What was the source of its subject matter?

15. List two stylistic features shared by the fresco of *Christ in Majesty* from Santa María de Mur (FIG. 17-17) and the *Christ in Majesty* from Toulouse (FIG. 17-7).

a.

b.

16. Why is the seated virgin shown in FIG. 17-18 known as the "Throne of Wisdom"?

HOLY ROMAN EMPIRE

1. Define the following architectural terms:

Campanile

compound pier

groin vault

alternating support system

2. The main drawback of barrel vaulting was:

What type of vault offered a solution to this problem?

In the nave of the German cathedral of Speyer (FIG. 17-19) this type of vault was combined with the _____ system used at St. Cyriakus Gernrode (FIG. 16-21).

3. The most important Romanesque church in Lombardy Italy is:

It retains the Early Christian feature of an:

The building has square bays and is vaulted with _____ vaults, which create a domical effect.

4. How do the proportions of height to width of Italian medieval churches compare to those of German churches?

5. Who was Hildegard of Bingen and what is the subject of the page from the *Scivias* shown in FIG. 17-22?

What does the work tell us about the achievements of an outstanding medieval woman?

6. List three classicizing features seen in the baptismal font done by Rainer of Huy (FIG. 17-23):

 a.

 b.

 c.

7. What is the purpose of the silver head of Saint Alexander shown in FIG. 17-24?

ITALY

1. List three features that Pisa Cathedral shares with its Early Christian prototypes.
 a.

 b.

 c.

 List four features that distinguish it from them:

 a.

 b.

 c.

 d.

2. List two Tuscan Romanesque buildings in Florence:

 a.

 b.

3. What features did the twelfth century Italian sculptor Benedetto Antelami adapt from Greco-Roman prototypes?

However, he did not take over the characteristic pose of Greco-Roman prototypes, which is known as:

NORMANDY AND ENGLAND

1. Define:

rib vaults

sexpartite vault

three story elevation

quadrant arch

1. The nave of St. Étienne at Caen (FIGS. 17-32) has a light and airy feeling. What structural features made this possible?

2. Two key elements of Gothic architecture were combined for the first time in the vaults of Durham Cathedral. What are they?
 a.

 b.

3. What is depicted on the *Bayeux Tapestry (FIG. 17-35)?*

What technique was used to create it?

4. How has the Romanesque style as seen in the *Bury Bible* (FIG. 17-36) been modified from earlier examples?

DISCUSSION QUESTIONS

1. What are the distinguishing features of the Romanesque style seen in the church of *Saint Sernin* at Toulouse (FIGS. 17-4 to 17-6) when compared with *Old Saint Peter's* in Rome (FIG. 11-9).

2. Describe the various evolutionary steps, in both plan and elevation, that led from the Carolingian to the Romanesque style in northern European churches.

3. What evidence do you see that the *Christ in Majesty* from *Saint Sernin* (Fig. 17-7) might have been derived from a metal prototype such as the cover of the *Lindau Gospels* (FIG. 16-16)?

4. What features indicate the common stylistic derivation of the fresco from Santa María de Mur (FIG. 17-32) and the apse mosaic from Monreale (FIG. 12-25)? What differences do you see?

5. What portents of change appear in the illumination depicting the scribe Eadwine from the *Eadwine Psalter* (FIG. 17-37)? Compare the treatment of the drapery and the body of Eadwine with that in the illustrations from the *Bury Bible* (FIG. 17-36) and the Evangelist from the *Ebbo Gospels* (FIG. 16-14).

6. Why do you think Bernard of Clairvaux was so disturbed by the sumptuous art of the churches. Do you agree with him?

LOOKING CAREFULLY AND ANALYSING

Write at least two pages comparing the manuscript illuminations of two authors: David composing the Psalms sown in the *Paris Psalter* FIG. 12-28 with the miniature of Hildegard von Bingen receiving inspiration for the *Scivias* shown on FIG. 17-22. First put down the title and medium of each. Then examine the colors, describing the hues, the values and the tonality. Note the background and describe the architectural and landscape forms. Describe the way the figures relate to the space and how the bodies relate to the drapery. What mood is created by each image and what features of the images work to create that mood? Which do you like best.

SUMMARY OF ROMANESQUE ARCHITECTURE

Romanesque Period: _____ to _____

Fill in as much of the chart as you can from memory. Check your answers against the text and complete the chart. Include additional material supplied by your instructor.

	Typical Examples	Stylistic Characteristics	Significant Historical Events, Ideas, etc.
France & Northern Spain			
Holy Roman Empire			
Italy			
Normandy & England			

SUMMARY OF ROMANESQUE SCULPTURE & PAINTING

Fill in as much of the chart as you can from memory. Check your answers against the text and complete the chart. Include additional material supplied by your instructor.

	Typical Examples	Stylistic Characteristics	Significant Historical Events, Ideas, etc.
Sculpture			
Painting & Textiles			
Manuscript Illumination			

18
THE AGE OF THE GREAT CATHEDRALS GOTHIC ART

TEXT PAGES 460-495

FRENCH GOTHIC

1. When and where did the Gothic style originate?

2. List three of the features of the new choir at St. Denis as described by Abbot Suger that are characteristic of the new Gothic style.

 a.

 b.

 c.

3. List the three structural and/or design features that characterize a Gothic vault.

 a.

 b.

 c.

 What are the advantages of the pointed arch over the round arch?

4. Identify the following:

Abbot Suger

Abelard

Saint Thomas Aquinas

Scholasticism

5. The new spirit of the Gothic period that replaced the severity of Romanesque themes of judgment and damnation could be symbolized by the dedication of cathedrals to _____. Her iconography can be seen in the Royal Portals of Chartres Cathedral, the earliest and most complete surviving Early Gothic sculptural complex.

The following scenes are represented on the tympana:

Right: Left: Central:

The figures carved on the jambs are thought to represent:

In what ways do these jamb figures differ significantly from Romanesque figures?

a.

b.

c.

6. List three Romanesque features retained in Laon Cathedral.

 a.

 b.

 c.

 List three new Gothic features found in the cathedral.

 a.

 b.

 c.

7. Draw a diagram of an Early Gothic elevation. Label the characteristic four stories: nave arcade, vaulted gallery, triforium, and clerestory.

8. What was the function of the flying buttress?

 Why was it an essential element of the Gothic architectural vocabulary?

9. Label the following parts of a Gothic church on the diagram below: **clerestory, flying buttress, nave arcade, pinnacle or finial, triforium, vaults.**

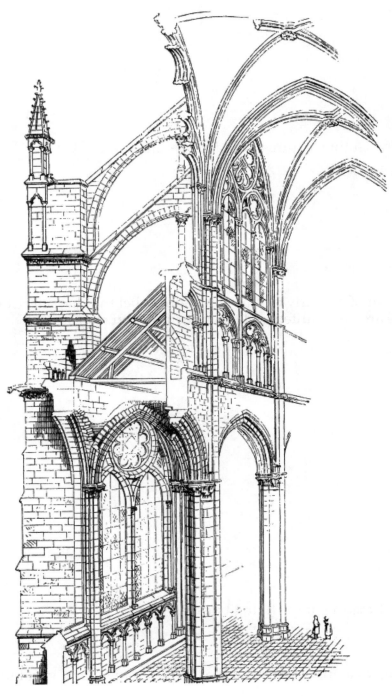

Is this an Early Gothic or High Gothic church? Why?

10. Describe or draw the new bay structure of Chartres that was to become the norm for High Gothic buildings:

What spatial effect did this create?

11. What segment of an Early Gothic elevation was eliminated in High Gothic buildings?

What technical development made this possible?

12. What was the theological significance of stained glass windows?

What is the difference between a rose window and a lancet? Draw and label them.

What is the difference between plate tracery and bar tracery?

13. How do the figures of *St. Martin, St. Jerome, and St. Gregory* from the Porch of the Confessors (FIG. 18-17) and the jamb figures from the Royal Portals of Chartres Cathedral (FIG. 18-7) illustrate the development of Gothic sculpture?

14. The skeletal structure and the high vaults of Amiens Cathedral were possible because of the masterful use of the High Gothic structural elements. List the four basic elements.

 a.

 b.

 c.

 d.

15. What are the similarities in the facades of Chartres (FIG. 18-5) and Amiens (FIG. 18-21)?

 What are the differences?

 What major change do you see in the façade of Reims (FIG. 18-23).

16. The Rayonnant (Radiant) style that developed in the second half of the13th century was associated with the court of _____.

17. What was the purpose of the Sainte Chapelle in Paris?

 How did its structure reflect that purpose?

18. Describe the pose of the Virgin of Paris (FIG. 18-26) that was typical of much later Gothic sculpture.

19. From what did the Late Gothic Flamboyant style derive its name?

 Give an example of the style:

20. Define the following:

 crenellations

 keep

 ramparts

21. How do the guild hall shown on FIG. 18-29 and the house of Jacques Coeur shown on FIG. 18-30 reflect the new economic conditions of Northern Europe in the Late Gothic period?

22. Who was Villard de Honnecourt and what did he use as the basis for drawing many of his figures?

23. In what way does the manuscript illumination illustrated on FIG. 18-34 reflect the influence of the arts of architecture or stained glass?

24. List three characteristics of the style of Master Honoré as seen in the illumination of *David and Goliath* shown in FIG. 18-35:

 a.

 b.

 c.

25. What features of the graceful image of the Virgin seen in FIG. 18-37 link her to the French court?

26. What is the meaning of the scene portrayed on the ivory casket shown in FIG. 18-38 and how does it relate to the concerns of the leisure class?

GOTHIC ART OUTSIDE FRANCE

1. List five features of Salisbury Cathedral that distinguish it from French Gothic:

 a.

 b.

 c.

 d.

 e.

2. The last English Gothic style, seen at Gloucester, is called_____.

 It is characterized by the following features:

 a.

 b.

3. Define or identify the following terms:

 fan vaulting

 ogee arch

 chantry

4. The German cathedral of _____was finished in the nineteenth century when the original thirteenth century plan was discovered. In what way was its Gothic construction significant for its survival of the severe bombings of World War II?

5. The church of St. Elizabeth at Marburg is an early example of a favorite German type of Gothic structure known as a: _____ _____.

How does it differ from the standard basilican type of church and what is the reason for the difference?

6. Briefly describe the style used in the depiction of the *Death of the Virgin* on Strasbourg Cathedral (FIG. 18-48).

7. Who were Ekkehard and Uta and what is significant about their appearance in a cathedral?

8. What is a Pieta?

What mood is created by the 14th century example shown in FIG. 18-51?

9. What art form was practiced by Nicholas of Verdun?

DISCUSSION QUESTIONS

1. Discuss the change in the role of women during the Gothic period and how it relates to the cult of the Virgin Mary. What effect did these changes have on art?

2. What effect did the changing philosophical conception of the relation between the soul and the body have on Gothic sculpture?

3. Select a typical Early Gothic and a High Gothic cathedral and explain the factors that differentiate one from the other.

4. Discuss the development of Medieval architectural sculpture considering the relation to its structural setting and the poses of the figures. Select from St. Sernin at Toulouse (FIG. 17-4), St. Pierre at Moissac (FIG. 17-1 and 17-11), the *Royal Portal* (FIG. 18-7) and *Porch of the Confessors* (FIG. 18-17) from Chartres, The *Beau Dieu* from Amiens (FIG. 18-22, *Saint Theodore* from at Chartres (FIG. 18-18), and the *Visitation* figures from Reims Cathedral (FIG. 18-24)?

5. What similarity do you see between the S-curve of *The Virgin of Paris* (FIG. 18-26) and that used by the Greek artist Praxiteles for the *Hermes* (FIG. 5-63)? In what ways are the two figures different?

6. In what ways has the classic French High Gothic structure as typified by Chartres Cathedral (18-13 to 18-15) and Amiens Cathedral (FIGS. 18-19 to and 18-21) been modified in the English buildings like Salisbury Cathedral (FIGS. 18-39 to 18-41).

7. Compare the figures of *Ekkehard and Uta* from Naumburg (FIG. 18-49) with the figures from Amiens (FIG. 18-20) and Reims (FIG. 18-22). How are the German figures related to the French prototypes? How do they differ?

8. The equestrian figure of the *Bamberg Rider* (FIG. 18-50) is reminiscent of that of the Roman emperor Marcus Aurelius (FIG. 10-59) and the Equestrian portrait of Charlemagne or Charles the Bald (FIG. 16-12). Compare the stylistic treatment of horse and rider as well as the relation of each figure to the space surrounding it.

9. Discuss patronage in the medieval period, including the roles played by clerics, guilds, merchants and royal patrons, noting specific examples of each.

10. Compare the representations of *Christ as Good Shepherd* (FIG. 11-16), *Christ as Panocrator* (FIG. 12-1), the *Beau Dieu* from Amiens (FIG. 18-22), and the *Rottgen Pieta* (FIG. 18-51). What emotional effect does each produce? Which do you like best? Why?

LOOKING CAREFULLY AND DESCRIBING

Look very carefully at the manuscript illumination of *God as Architect of the Universe* illustrated in FIG. 18-30. Describe it as fully as you can. Describe each element of the image: the hands, the fingers, the feet and toes, the tilt of the head, the hair, the eyes, the ear, the mouth, the pose and articulation of the body, the way the drapery reveals and hides the body, the instrument that God holds and the patterns on the sphere, the shape of the frame, the relation of the body to the frame, as well as the patterns on the frame. When you have finished, close the book, look at your description and see if you can draw the image relying only on the words you have written. If you can't do it, go back and more fully describe the sections that you had trouble understanding.

SUMMARY OF GOTHIC ART

Using the information on page 495 of the text, enter the approximate dates for the following periods.

Early Gothic Period:_____ to _____

High Gothic Period:_____ to _____

Late Gothic Period:_____ to _____

Fill in as much of the chart as you can from memory. Check your answers against the text and complete the chart. Include additional material supplied by your instructor.

	Significant Religious Leaders & Events	Significant Political Leaders & Events	Cultural Developments
Early Gothic			
High Gothic			
Late Gothic			

SUMMARY OF GOTHIC ARCHITECTURE

	Typical Examples	Stylistic Characteristics
French Early Gothic		
French High Gothic		
French Rayonnant		
French Late Gothic		
English Gothic		
German Gothic		

SUMMARY OF GOTHIC SCULPTURE & OTHER ARTS

	Typical Examples	Stylistic Characteristics
French Early Gothic Sculpture		
French High Gothic Sculpture		
French Late Gothic Sculpture		
German Gothic Sculpture		
Metalwork & Ivories		
Manuscripts		
Stained Glass		

19
ITALY, 1200 TO 1400

TEXT PAGES 496-517

THE 13TH CENTURY

1. Name one element in Nicola's pulpit in the Pisa Baptistery(FIG. 19-2) that shows the medieval tradition:

Name one element that shows the influence of classical antiquity:

2. List two characteristics of the Italo-Byzantine style (*maniera greca*):
a.

b.

Name an Italian painter who worked in the style:

3. Who was St. Francis?

What was the *stigmata*?

4. Name two mendicant orders:

Describe the influence they had on church architecture.

5. Although Cimabue was deeply influenced by the Italo-Byzantine style, he moved beyond it in the following ways:

a.

b.

THE FOURTEETH CENTURY

1. Identify the following:

Black Death

Campanile

Confraternity

Fresco

Grisaille

Humanism

2. What seem to have been the artistic traditions that influenced Giotto and contributed to
the shaping of his style?

List two characteristics of Giotto's style as seen by comparing his *Madonna Enthroned* (FIG. 19-8) with Cimabue's version of the same subject (FIG. 19-7).

 a.

 b.

Giotto created a great fresco cycle in the _____chapel
in _____ .

It was consecrated in the year _____. The subjects of the framed scenes deal with:

List four characteristics of Giotto's style as seen in the *Lamentation* scene (FIG. 19-9).

a.

b.

c.

d.

3. The subject of Duccio's *Maesta* (FIGS. 19-10 and 19-11) was :

List three stylistic elements he derived from the Byzantine tradition:

a.

b.

c.

List three ways in which he modified it:

a.

b.

c.

4. How is the façade of Orvieto Cathedral (FIG. 19-12) related to those of French Gothic churches?

5. How did Simone Martini help to form the so-called International style?

List four characteristics of that style.

a.

b.

c.

d.

6. How were artists trained in Italy during the 14ᵗʰ and 15ᵗʰ centuries?

7. Panoramic views of the city of Siena and its surrounding countryside were painted by _____ in the Palazzo Pubblico in Siena as part of a fresco known as _____ .

_____ .
What revolutionary aspects are found in this fresco (FIGS. 19-16 and 19-17)?

8. Florence cathedral was begun under the direction of:

List two features of the interior that add to its sense of spaciousness:

 a.

 b.

9. What historical event seems to be foreshadowed by the subject of *The Triumph of Death* (FIG. 19-20)?

 What message was the iconography most likely intended to convey?

10. What features of the Doge's Palace in Venice can be considered to be Gothic?

11. How do the proportions of Milan Cathedral (FIG. 19-22) compare with those of French Cathedrals like Amiens (FIG. 18-21)

DISCUSSION QUESTIONS

1. Discuss the effects of social and economic changes between the late thirteenth and late fourteenth centuries on Italian art of the period.

2. Compare the versions of the *Nativity* by Nicola and Giovanni Pisano (FIGS. 19-3 and 19-4) with the Late Antique *Ludovisi Battle Sarcophagus* (FIG. 10-70). How are the Pisani works similar to this Roman example? How are they different from it and from each other?

3. Compare Giotto's *Lamentation* (FIG. 19-9) with Duccio's *Betrayal of Jesus* (FIG. 19-11); note particularly the use of space, three-dimensional volume, and the sense of drama.

4. Compare Simone Martini's *Annunciation* (FIG. 19-13) with the *Virgin of Jeanne d'Evreux* (FIG. 18-37). Can you find any stylistic characteristics of the French figure that can be related to those of Simone's version? Discuss the historical factors that account for the French influence in his work.

5. Compare Florence Cathedral (FIGS. 19-18 and 19-19) with Cologne Cathedral (FIGS.18-47 and 18-48) Note especially the way in which decorative details are integrated with the construction as a whole. What design features does Florence Cathedral share with Orvieto Cathedral (FIG. 19-12) and Milan Cathedral (FG. 19-22)?

LOOKING CAREFULLY, DESCRIBING AND ANALYZING

Look carefully at Lorenzetti's *Effects of Good Government* in the city and in the country (FIGS. 19-16 and 19-17) and compare them to the landscape and architectural scenes in on Berlinghieri's *St. Francis* altarpiece (FIG. 19-5). Write a one page essay analyzing each of the images using the following terms: form and composition; material and technique; space, mass and volume, line, and color. Here are some questions that might help you with your analysis, but do not be limited by them. What differences do you see in the artists' approaches to composition and form, particularly in the depiction of space? How does each artist describe architectural forms and the forms of the mountains? In each case how are human figures related to the environment both in scale and position. Which has the greatest sense of space? Which elements contribute to that sense?

SUMMARY OF ART & ARCHITECTURE IN ITALY 1200-1400

Fill in as much of the chart as you can from memory. Check your answers against the text and complete the chart. Include additional material supplied by your instructor.

	Typical Examples	Stylistic Characteristics	Significant Historical Events, Ideas, etc.
Nicola Pisano City:			
Giovanni Pisano City:			
Berlinghieri City:			
Duccio City:			
Cimabue City:			
Giotto City:			
Lorenzetti City:			
Traini City:			
Orvieto Cathedral:			
Florence Cathedral:			
Milan Cathedral:			

PREPARING FOR YOUR EXAMINATIONS

As you prepare to take your examination you should review the notes you took on your lectures as well as the work you did in your Study Guide. (Look back at the **Introduction to the Study Guide** for tips on taking notes and creating your own charts, as well as detailed instructions on studying for and taking examinations.) If you have not yet filled out the Summary charts in the Guide, this is the time to do it, integrating materials from your lecture notes with materials in the Guide itself. This activity is the most useful thing that you can do.

The self-quiz included below as well as the materials included in the **Companion Site** for the textbook can be a great help in preparing you for course examinations. The quiz below includes types of questions often asked in art history exam examinations: multiple choice, short answer questions, chronology exercises, essay questions and attribution of unknown images. So take the self-quiz and check your answers in the back of the Guide so that you can see how well you grasp the material. If you are unclear about certain areas review the text and utilize the on-line Infotrac research tool on the companion site to fill in the gaps.

Self-Quiz
THE ANCIENT WORLD IN THE WEST

CHAPTERS 1, 2, 3, 4, 5, 9, 10, 11

MULTIPLE CHOICE
Circle the most appropriate answer.

1. Minoan columns are distinguished by:
 a. bud-shaped capitals b. a pronounced swell in the center of the column
 c. bull-shaped capital d. tapering shape and bulbous capitals

2. Figurines of priestesses or goddesses holding snakes would most likely be found in:
 a. Nimrud b. Knossos c. Mycenae d. Khorsabad

3. The Ishtar Gate was built by the:
 a. Sumerians b. Egyptians c. Minoans d. Babylonians

4. The Persians took over the use of large, winged bull-man guardian figures from the:
 a. Sumerians b. Minoans c. Greeks d. Assyrians

5. The dome of Hagia Sopia is supported by:
 a. the oculus b. squinches c. pilasters d. pendentives

6. Predominant themes found in the art of the Assyrians were:
 a. dancing girls and women sacrificing b. war and hunting
 c. the sun disk Aton and Amenophis praying d. scenes from the afterlife

7. Which of the following was NOT a Greek sculptor:
 a. Euripides b. Praxiteles c. Polykleitos d. Lysippos

8. A pylon was a:
 a. multi-stepped platform that served as support for a temple
 b. type of Old Kingdom Egyptian tomb
 c. monumental Egyptian entrance gate with sloping sides
 d. megalithic stone circle

9. A vase with curvilinear motifs of octopuses would most likely be found in:
 a. the royal Cemetery at Ur b. Amarna c. a ziggurat d. the palace at Crete

10. Persian relief figures can be distinguished from earlier Mesopotamian relief figures by:
 a. the bulging muscles b. showing shoulders in profile
 c. use of extremely large eyes d. use of bas-relief

11 A megalithic stone circle was erected at:
 a. Stonehenge b. Saqqara c. Khorsabad d. Ur

12. During the Period of Persecution, Christ was most often represented:
 a. as Ruler of the World b. with a halo c. as the Good Shepherd d. on the cross

13. The Propylaea was:
 a. a Roman temple b. an Etruscan fortification
 c. the entrance gate to the Athens Acropolis d. part of the forum of Trajan

14. A relief showing the spoils from the Temple of Jerusalem is carved in an arch in:

 a. Babylon b. Athens c. Jerusalem d. Rome

15. The courtyard in front of Old Saint Peter's was called the:

 a. atrium b. narthex c. nave d. bema

16. A favorite subject of Greek Achaic sculptors was a standing, nude male figure called a:

 a. kouros b. tholos c. kylix d. cista

17. Pompeian wall paintings of the Second Style were characterized by:
 a. fantastic architecture based on the theater b. copies of inlaid stone materials
 c. the wall seemingly opening out into an illusionistic space d. bas-relief panels

18. An Attic black-figure vase showing of Ajax and Achilles playing a game was created by:

 a. Imhotep b. Phidias c. Exekias d. Polykleitos

19. The tomb of Rameses II was located in:

 a. Persepolis b. Mesopotamia c. Crete d. Egypt

20. The Palaces of Xerxes and Darius were created by the:

 a. Akkadians b. Babylonians c. Persians d. Mycenaeans

21. Which of the following was NOT a Paleolithic site?

 a. Pechemerle b. Altamira c. Stonehenge d. Lascaux

22. The Venus of Willendorf can best be described as a:
 a. Neolithic figure of clay found in Jordan b. Greek classical nude by Praxiteles
 c. small stone Paleolithic figurine d. Egyptian fertility figure found at Saqqara

23. A lintel would NOT be found on or at:
 a. Stonehenge b. Lascaux c. Parthenon d. Mortuary Temple of Hatshepsut

24. The Standard of Ur is illustrated with:
 a. two lions flanking an inverted column b. Akhenaton's portrait
 with the Ankh
 c. scenes of war and peace d. the Battle of Issus with Darius and
 Alexander

25. Which of the following does NOT fit the set:
 a. Gudea of Lagash b. fiHammurabi c. Sargon d. Phidias

26. A great female ruler of Egypt was
 a. Livia b.Ramses c. Hatshepsut d. Galla
 Placidia

27. Which of the following is NOT true regarding the Augustus of Primaporta?
 a. It celebrated the Pax Romana.
 b. The pose was based on that of Polykleitos' Doryphoros.
 c. It showed the emperor as a nude hero.
 d. It illustrated the divine descent of Augustus' family.
 e. The curass showed the return of Roman standards captured by the
 Parthians.
 f.
28. Which of the following buildings is NOT in Rome?
 a. Pantheon b. Markets of Trajan c. Arch of Constantine d. Pont-
 du-Gard

29. A chimera is a:
 a. creature with the body of a lion the tail of a snake and a goat emerging
 from the body.
 b. winged, man-headed bull who served as a palace guardian.
 c. human-headed lion who guarded the pyramids.
 d. winged-horse who was born of a gorgon.

30. An iwan would most likely be found in:
 a. Italy b. France c. England d. Iran

31. Cuneiform was:
 a. script used by the ancient Sumerians and Akkadians .
 b. Phoenician script that formed the basis of the Greek alphabet.
 c. picture writing developed by the Egyptians.
 d. ancient script translated by Champollion.

32. An early code of laws was inscribed on the:
 a. Stele of Naram-sin b. Palette of King Narmar
 c. walls of Dura-Europas d. Stele of Hammarabi

33. Which of the following was decorated with frescos?
 a. Santa Costanza b. Mausoleum of Galla Placidia
 c. Sant'Apollinare Nuovo d. Synagogue of Dura-Europas

34. Greatly simplifed marble figures from the Bronze Age are typical of the style known as:
 a. Cycladic b. Mycenean c. Spartan d. Minoan

35. Which of the following does NOT belong to the set:
 a. Hathor b. Isis c. Gilgamish d. Osiris

36. Sarcophagi which showed both husband and wife reclining on the top were created by
 a. Sumerians b. Akkadians c. Minoans d. Etruscans

37. We know a great deal about the daily life of the Romans because of:
 a. excavations by Sir Arthur Evans b. excavations by Heinrich Schliemann
 c. the explosion of Vesuvias d. the explosion of Krakatoa

38. An important early synagogue was found at:
 a. Dura-Europas b. Troy c. Knossos d. Mycenae

39. Which of the following is not a Greek sculpture or a copy of one?
 a. Caryatid from the Erechtheion b. Nike of Samothrace
 c. Ara Pacis d. Altar of Zeus at Olympia

40A&B

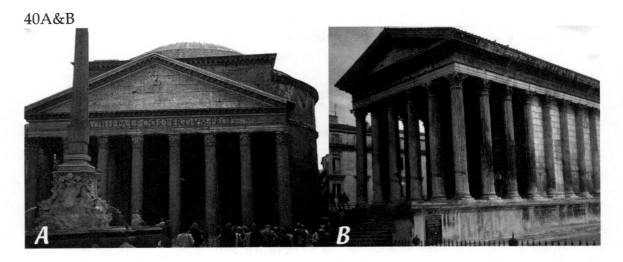

40. The culture that created the building shown in 40A was the:
 a. Greeks b. Etruscans d. Egyptians e. Romans

41. The culture that created the building shown in 40B was the:
 a. Greeks b. Etruscans d. Egyptians e. Romans

42. The building shown in 40A is located in:
 a. Rome b. Athens c. Milan d. France

43. Features of the building shown in 40B that were most influenced by the Greeks are:
 a. the colonnade and the pediment b. the pseudo-peripteral style
 c. the high podium d. both b and c

44 . Features of the building shown in 40B that were most influenced by the Etruscans are:
 a. the colonnade and the pediment b. the pseudo-peripteral style
 c. the high podium d. both b and c

45A&B

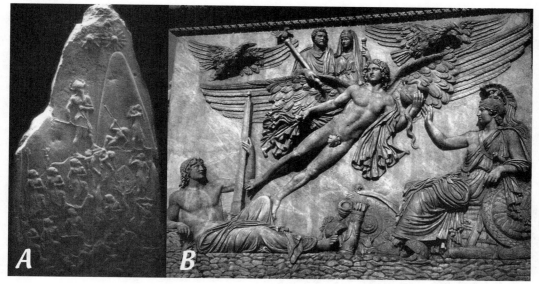

45. The culture that created the relief shown in 45A was located in the:
 a. Mesopotamia b. Crete d. Egypt e. Mycenae

46. The scene in the relief shown on 45A illustrates the:
 a. Victory Stele of Naram Sin b. Akhenaton's victory over the
Nubians
 c. Sumerian king doing astrology c. Victory of Darius over Alexander

47. Important stylistic feature (s) of the relief shown in 45A is
 a. the relative size of the main figure b. the mountain
 c. shoulders full front and legs in profile d. both a and c

48. The culture that created the relief shown in 45B was the:
 a. Greeks b. Etruscans d. Romans e. Christian

49. The scene depicted in the relief shown on 45B is:
 a. the apotheosis of Antonius Pius & Faustina
 b. glorification of Akhenaton and Nefertiti
 c. two Christian souls being taken to heaven
 d. Constantine and St. Helena

50A,B&C

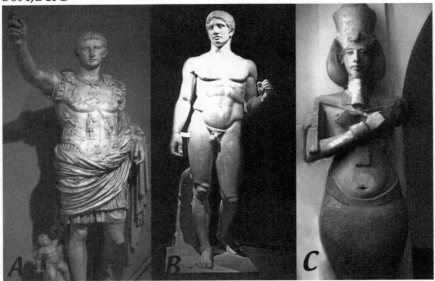

50. The culture that created the figure shown in 50A was :
 a. Roman Republic b. Roman Empire c. Late Antique d. Greek

51. The man portrayed in the sculpture shown in 50A was:
 a. Constantine b. Pericles c. Augustus d. Trajan

52. The culture that created the prototype of the figure shown in 50B was :
 a. Etruscan b. Roman Republic c. Persian d. Greek

53. The sculptor who created the original of the figure shown in 50B was:
 a. Phidias b. Polykleitos c. Praxitiles d. Hermes

54. The figure shown in 50C was created during the :
 a. Egyptian Old Kingdom b. Egyptian Middle Kingdom
 c. Egyptian New Kingdom d. Ptolemaic Period

55. The pharaoh portrayed in the sculpture shown in 82C was:
 a. Tutankhamen b. Menkare c. Akhenaton d. Kafre

56A,B&C

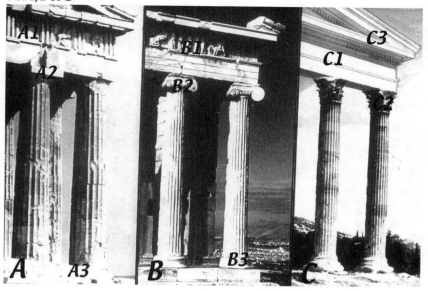

56. The architectural style depicted in 56A is known as:
 a. Doric b. Aeolian c. Ionic d. Corinthian

57. Name the type of frieze shown in 56A1 is called:
 a. Continuous b. Triglyph-Metope c. Bucranian d. Architrave

58. The architectural style depicted in 56B 56A is known as:
 a. Doric b. Aeolian c. Ionic d. Corinthian

59. The type of capital shown in 56B2 is called:
 a. Aeolian b. Pillow c. Volute d. Corinthian

60. The architectural style depicted in 56C 56A is known as:
 a. Doric b. Aeolian c. Ionic d. Corinthian

61. The architectural element shown in 56C1 is known as the:
 a. architrave b. raking cornice c. stylobate d. naos

62A&B

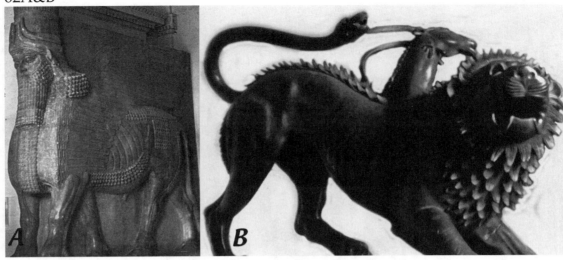

62. The culture that created the figure shown in 62A was :
 a. Sumerian b. Assyrian c. Etruscan d. Babylonian

63. The creature depicted in 62A was called a:
 a. chimera b. gigantomachy c. lamasu d. sphinx

64. The function of the figure shown in 62A was :
 a. guardian of a temple b. guardian of a palace
 c. marker for a place of sacrifice d. guardian of the king's bulls

65. The culture that created the figure shown in 62B was :
 a. Sumerian b. Assyrian c. Etruscan d. Babylonian

66. The creature depicted in 62B was called a:
 a. chimera b. gigantomachy c. lamasu d. lion-goat

CHRONOLOGY EXERCISE
Put the letters corresponding to specific art works under the appropriate date range:

67. Bull Leaping fresco, Knossos a. 25,000-10,000 BCE

68. Lion Gate, Mycenae b. 8,000-3,100 BCE

69. Column of Trajan, Rome c. 3,000-1,000 BCE

70. Kouros from Attica d. 750-1 BCE

 e. 1 CE-500 CE

71. Frescos from Lascaux

72. Stele of Hammurabi

73. Queen Nefertiti

74. Cycladic idol

75. Laocoon

76 Pyramid of Khafre, Gizeh

77. Dying Gaul, Pergamon

78. Santa Costanza, Rome

79. Gold Funerary Mask, Mycenae

80. Stonehenge

81. Harvester's Vase, Crete

82. Villa of the Mysteries, Pompeii

83. Standard of Ur

84. Good Shepherd from Catacomb of SS Peter & Marcellinus

85. Pediment from Temple of Zeus, Olympia

86. Temple of Athena Nike, Athens

87. Theater of Epidaurus

88. Synagogue of Dura Europus

89. Palace of Sargon II, Khorsabad

90. Ishtar Gate, Babylon

91. Tomb of Zoser, Saqqara

92. Parthenon

93. Shrine of Çatal Hoyük

94. Mausoleum of Galla Placidia, Ravenna

95. Coffin of Tutankhamen

96. Pantheon, Rome

97. Stele of Naram Sin

98. Apulu (Apollo) of Veii

99 Kritios Boy

100. Nike (Victory) of Samothrace

101. Temple of Ramses II, Abu Simbel

102. Ara Pacis Augustae, Rome

103. Old Saint Peter's, Rome

104. Altar of Zeus, Pergamon

105. Palette of Narmar, Egypt

106. Venus of Willendorf

SHORT ANSWER QUESTIONS
Answer the question or finish the sentence.

107. What seems to have been the purpose of Paleolithic cave paintings:

108. Describe an architectural feature used at Persepolis that seems to have been uniquely Persian.

109. How do the reliefs on the Palace of Darius at Persepolis reflect the purpose of the building?

110. Describe three stylistic conventions found in Sumerian art:

111. Why was the discovery of the Rosetta Stone important for the study of art?

112. Describe the post and lintel system:

113. What is a mastaba and what was its purpose?

114. Name one shape used by the Egyptians on capitals and note the relationship it had to the Egyptian environment.

115. What was the importance of Amarna in the development of Egyptian art?

116. What features of the architecture of the Palace of Knossos might have given rise to the legend of the labyrinth?

117. Describe a corbelled vault:

118. What contribution did Polycleitos make to the portrayal of the human figure?

119. In what way was Phidias involved with the Parthenon?

120. During what period did Greek sculptors carve with the greatest degree of realism?

121. What is herringbone perspective and who used it?

122. What significance did the eruption of Vesuvius in 79 have for the history of art?

123. Describe a groin vault and state its advantage over a barrel vault:

124. Name three types of buildings that were commonly found in connection with a Roman forum:

125. How does an arcade differ from a post and lintel system?

126. What is an equestrian portrait? Name a Roman emperor who was thusly portrayed:

127. The Roman emperor who recognized Christianity as an official religion of the state was:

128. What was the purpose of the Pantheon?

129. Describe a ziggurat and explain its purpose.

130. What feature characterizes a peripteral temple?

131. Why is the town plan of Priene important for the history of urban design?

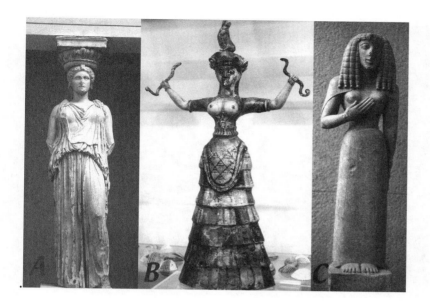

132. What culture created the figure on 132A?

133. What is the function of the figure on 132A?

134. What culture created the figure on 132B?

135. Place these three figures in chronological sequence:

136A&B

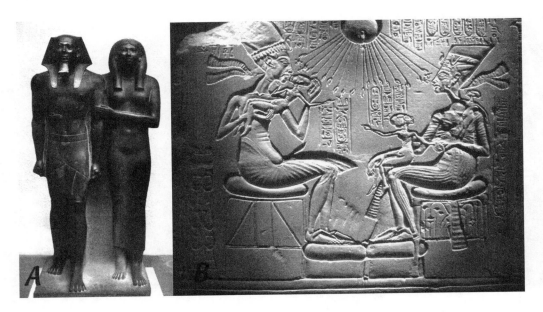

136. What culture created the figure on 136A and 136B?

137. Name the period or style of figure 136A

138. What was the function of the figures shown in 136A:

139. Name the period or style of figure 136B:

140. What is depicted in figure 136B?

141. Write a few sentences explaining the religious differences shown in these two works of art:

142A&B

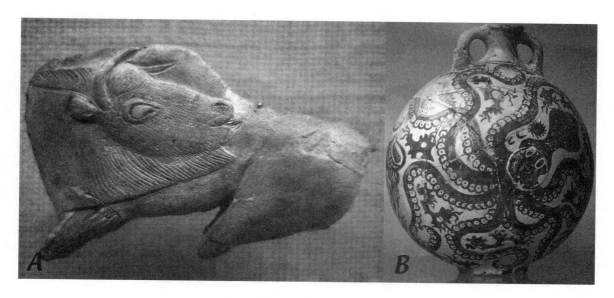

142. What culture created the figure on 142A?

143. Briefly state how the creature depicted relates to the culture:

144. What culture created the vase shown on 142B?

145. Briefly state how the creature depicted relates to the culture:

146. What culture created the object shown on 146A?

147. What is the function of the object shown on 146A?

148. What can be inferred from 146A about the status of women in that culture as compared to Greek woman?

149. What culture created the sarcophagus shown on 146B:

150. What religious faith did the owner of the sarcophagus belong to?

151A,B&C

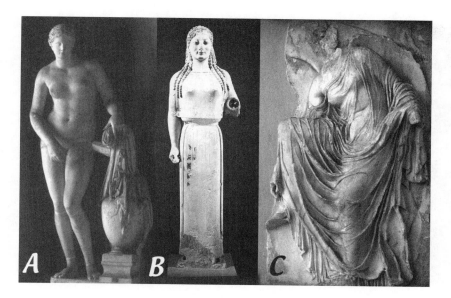

151. Name the culture that created the figure shown in 151A:

152. Name the sculptor who created the original of the figure shown in 151A:

153. Name the culture created the figure shown in 151B:

154. Name the style of the figure shown in 151B:

155. In what century was the figure shown in 151C carved?

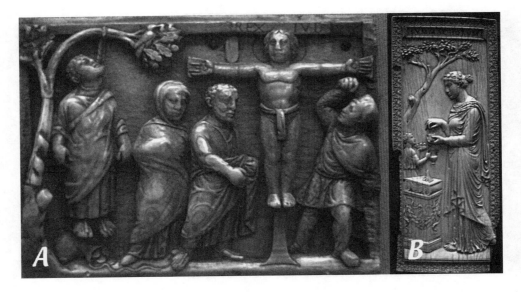

156. What religion is represented in the work shown on 156A?

157. What scene is illustrated in the work shown on 156A?

158. What scene is illustrated in the work shown on 156B?

159. These two works were carved of the same material . What is it?

160. Briefly explain the political and religious situation that gave rise to two such different images that were created within approximately 20 years of each other.

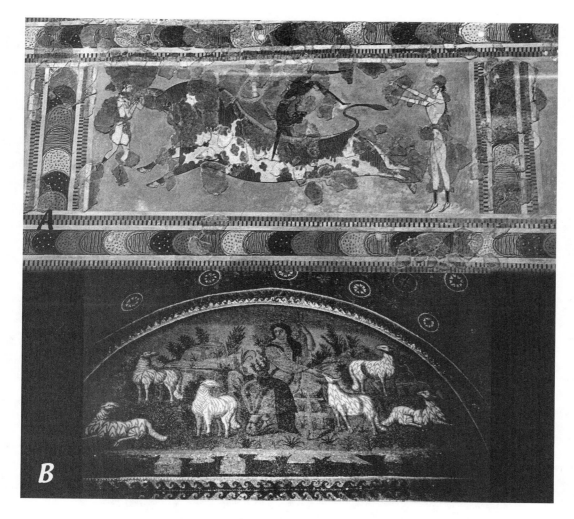

161. Name the culture that created the figure shown in 161A:

162. What is being represented in figure 161A?

163. Name the culture that created the figure shown in 161B:

164. What is being represented in figure 161B?

165. What material was used to create the image shown in 161B?

ANALYSIS OF UNKNOWN IMAGES

166. Compare the following reliefs, attributing each to a culture and providing an approximate date. Give the reasons for your attributions, citing stylistic characteristics each work shares with similar works you have studied.

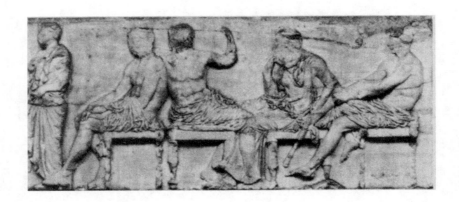

A. Culture: Date:

 Reasons:

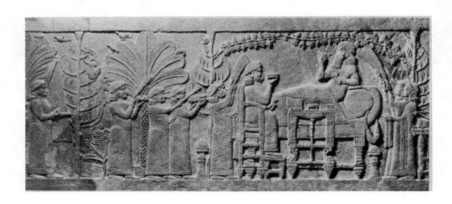

B. Culture: Date:

 Reasons:

167. What group built the building illustrated below? Approximately when was it erected? Give the reasons for your attributions, citing stylistic characteristics.

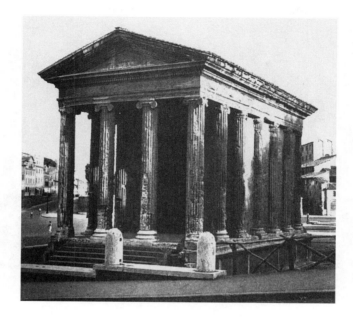

Culture: Date:

Reasons:

168. Compare the following heads, attributing each to a culture and providing an approximate date. Give the reasons for your attributions.

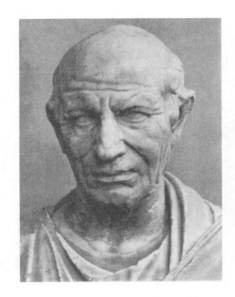

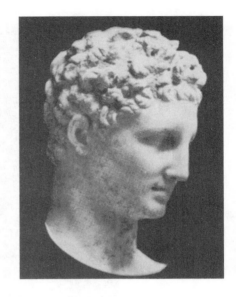

A. Culture:

 Date:

 Reasons:

B. Culture:

 Date:

 Reasons:

169. Compare the following two works, attributing each to a culture and providing an approximate date. Give the reasons for your attributions.

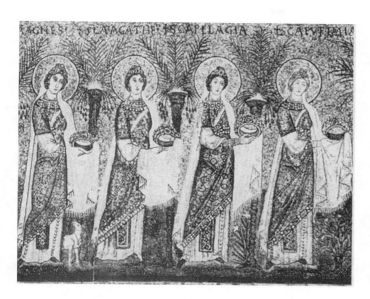
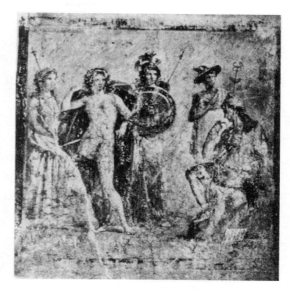

A. Culture:

Date:

Reasons:

B. Culture:

Date:

Reasons:

ESSAYS

Select one essay, and be sure and cite specific examples to illustrate your argument.

A. Discuss the development Roman portraiture by selecting at least four portraits from the Roman Republic through the late Antique period. What changes do you see and how do they relate to the changing social and political situation?

B. Compare the Greek and Roman approaches to architecture. What type of space did each create, and in what way did the materials and techniques contribute to the effects created.

C. Compare the approach to the human figure that one finds in Egyptian and Greek sculpture. Describe the formal qualities one finds in the two traditions. What influence might their religious and political ideas have on the way the figures are depicted?

QUIZ ANSWERS
ANCIENT WORLD IN THE WEST

MULTIPLE CHOICE

1. e	2. b	3. c	4. e	5. d	6. b	7. d	8. d	9. e	10. b	11. a	12. c
13. c	14. d	15. a	16. a	17. c	18. c	19. d	20. c	21. c	22. c	23. b	24. c
25. d	26. c	27. c	28. d	29. a	30. d	31. a	32. d	33. d	34. a	35. c	36. d
37. c	38. a	39. c	40. e	41. e	42. a	43. a	44. d	45. a	46. a	47. d	48. a
49. a	50. b	51. c	52. d	53. b	54. c	55. c	56. a	57. b	58. c	59. c	60. d
61. a	62. b	63. c	64. a	65. c	66. a						

CHRONOLOGY

67. c	68. c	69. e	70. d	71. a	72. c	73. c	74. c	75. e or d	76. c	
77. d	78. e	79. c	80. c	81. c	82. d or e		83. c	84. e	85. d	86. d
87. d	88. e	89. d	90. d	91. c	92. d	93. b	94. e	95. c	96. e	97. c
98. d	99. d	100. d	101. c	102. e	103. e	104. d	105. b	106. a		

SHORT ANSWERS

107. They seemed to be involved in a ritual that was associated with the hunt.

108. Capitals with the foreparts of lions or bulls.

109. The reliefs of subject nations bringing tribute to the Persian ruler and the complex palace ceremonials echoed the purpose of the great palace, which was intended to symbolize Persian power.

110. Sumerian relief sculptures share the Egyptian conventions of showing figures in profile with shoulders full front. The poses are regularized and repeated. An oval shape is used for full round sculpture; eyes are large and hands are often clasped.

111. The stone inscribed in Greek, demotic and hieroglyphics enabled scholars to decipher the means of the hieroglyphic symbols and thus understand the meaning of the reliefs they accompanied.

112. A simple structural system in which two vertical members support a horizontal member.

113. It is an ancient Egyptian tomb in the shape of a bench or truncated pyramid.

114. Bud, flower and bell shaped, but might also include the shape of human heads. The plant formed often echoed the lotus and papyrus plants found in the environment.

115. The Pharaoh Akhenaton established his new capital in Amarna, and it became the center of the Amarna artistic style.

116. The complexity of the palace plan.

117. A corbelled vault is created by courses of stone laid on a circular base, each course overlapping the previous one. The thrust of the vault is supported by the dirt that surrounds the dome.

118. Polykleitos developed a system of proportions for the human figure in which every part is related to every other part.

119. Phidias was in charge of the artists who created the sculptures for the building.

120. Hellenistic

121. In herringbone perspective the lives of projection converge in a vertical axis rather than in a single point on the horizon. It is found in Roman fresco paintings.

122. In covering Pompeii and Herculaneum it preserved their art and architecture for later study.

123. A groin vault results from the intersection of two barrel vaults. Groin vaults allow more light to enter a building than did barrel vaults.

124. A basilica or judicial building, a curia or civic center, and temples were commonly found in connection with roman forums.

125. An arcade combines arches with columns, while a post and lintel system uses a flat element on top of the columns.

126. An equestrian portrait shows a person mounted on a horse. Marcus aurelius was portrayed on horseback.

127. Constantine.

128. The Pantheon was a temple dedicated to all the gods .

129. A ziggurat was a stepped pyramid with a temple on the top and it was used as a site to worship the gods.

130. A peripteral temple has a colonnade going all the way around.

131. The city plan was laid out with intersecting lines creating a grid. It served as a model for many later city plans.

132. Greek classic.

133. Served as a caryatid, a figure serving the same function as a column.

134. Minoan.

135. B, C, and A.

136. Egyptian.

137. Old Kingdom.

138. Served as figures who provided a home for the pharaoh's Ka or spirit.

139. New Kingdom or Amarna period.

140. Akhenaton and Nefertiti and their daughters with the sun or Aten, sending its rays holding ankh or symbol of eternal life.

141. The pharaoh and his queen on the left illustrate the traditional beliefs in many gods and with the pharaoh personifying the gods on earth and returning to them in the afterlife. The relief of Akhenaton and Nefertiti illustrate a monotheistic religious revolution that they tried to bring about.

142. Paleolithic.

143. The strength and power of bulls were apparently very much admired by Paleolithic peoples who portrayed them in caves and other carvings. Not only were they a source of food, but they probably also symbolized fertility.

144. Minoan

145. The octopus and other sea creatures on the vase illustrate the Minoan dependence on the sea which surrounded their island.

146. Etruscan

147. A sarcophagus used for burial of the dead.

148. Greek spouses lived rather different lives with wives not attending parties and rarely shown together as were these two Etruscan spouses who recline together in death on a couches like the one they would have shared at various gatherings.

149. The sarcophagus was carved by Roman craftsmen.

150. The owner of the sarcophagus was a Christian. Various Christian scenes are represented from both the Old and New Testaments.

151. Greek classic period.

152. Praxiteles.

153. Greek.

154. Archaic.

155. 5th or 4th century BCE

156. Christian.

157. Crucifixion of Christ with Judas hanging himself.

158. Here a priestess makes an offering on a pagan altar.

159. Ivory

160. Christianity was recognized in the 4th century and became Rome's official religion shortly thereafter. The crucifixion ivory speaks to the new religion, but not all Romans adopted it. The ivory on the right shows a pagan religious ceremony and was used to announce the wedding between two pagan families.

161. Minoan

162. The Minoan ceremony of bull jumping.

163. Christians created the image during the Roman late antique period.

164. Christ as the Good Shepherd is represented here, but the image was ceated after the recognition as is indicated by Christ's halo and rich garments.

165. Mosaic.

ANALYSIS OF UNKNOWN IMAGES
In each of the answers to the analysis questions, the first date provided is the range within you should have dated the work, the second date — in parenthesis — is the actual date accepted by scholars.

166. A. Greek, fifth century B.C.E. (Detail from the Parthenon frieze, c. 440-423 B.C.E. British Museum, London.)

 B. Assyrian, ninth to seventh centuries B.C.E. (*Banquet Relief of King Ashurbanipal, Nineveh*, 668-627 B.C.E. British Museum, London.)

As you compare these two reliefs, which illustrate the differences between the Assyrian and Classical Greek handling of relief sculptures, you might have made the following observations. The Greek relief shows the same characteristics that were noted in the other reliefs from the Parthenon: the balance between the "ideal" and the "real," between the tactile and optical approaches to form. The texture of the drapery folds contrasts with the smooth, monumental forms of the bodies. The human figures are the dominant element in the relief; a plain background and a few props give only a summary indication of the setting. The greater three-dimensionality of the Greek relief contrasts with the lower bas-relief technique used by the Assyrians. In contrast to the relaxed and idealized Greek figures, which seem to be engaging in easy and familiar conversation, the conventionalized Assyrian figures seem stiff and tense. While the Classical Greek figures are fully understood anatomically and move freely and naturally in space, the Assyrian figures are rendered in an age-old combination of front and side views. The short, stocky, heavily muscled figures are characteristic of the reliefs of both Ashurnasirpal II and Ashurbanipal, as are the tight curls of hair and beard. The stylized details of the plant forms and the furniture are combined to reinforce a rather stiff formality similar to that of the Assyrian reliefs illustrated in the text.

167. Roman, Republican period, second century B.C.E. to first century A.D. (*Temple of Fortona Virilis,* Rome, beginning of first century B.C.E.)

Although this temple bears a close resemblance to a Greek peripteral temple, it is obviously Roman for several reasons: Like the Maison Carrée in Nîmes, it is set on a high podium and is approached by stairs only from the front. Greek temples, by contrast, which were ordinarily set on the tiered stylobate and stereobate, were much more easily approached from all sides. The cella of this temple, like that of the Maison Carrée extends the full width of the podium, with the result that the columns around the cella are attached to its walls as engaged columns, and only those of the porch are free-standing. This type of construction is known as "pseudoperipteral" and was very popular with Roman architects. Another typically Roman feature is the use of the Corinthian order, which was used by Roman architects more often than were the Greek Doric and Ionic orders.

168. A. Roman, second century B.C.E. to first century A.D. (*Roman Head,* Republican period, first century B.C.E. Glyptotheck, Munich.)

B. Greek, fifth to fourth centuries B.C.E. (Praxiteles, *Head of Hermes,* detail of *Hermes and Dionysos,* C. 340 B.C.E. Museum, Olympia.)

These two heads illustrate the contrast between Greek idealism and Roman realism. As you identified them, you probably noted the difference between the youthful beauty of the Greek head and the mature dignity of the Roman head. The Greek head has the rounded face, the slightly pouting lips, small eyes, and straight nose and brow line that are characteristic of heads from the Classical period. The locks of the hair are loosely rendered, and shadows that slightly soften the formal perfection of the features are apparent. Around the eyes, a softening that is seen in the style of Praxiteles, In contrast to the smooth perfection and generalization of the features of the Greek face, the Roman face is deeply lined and strongly particularized. The wrinkles seem to be his and his alone, etched by profound experiences of life. With painstaking care the artist has indicated every change in the contour of the face, an approach to portraiture that was particularly popular during the years of the Roman Republic and that has been called "veristic."

169. A. Early Christian or Early Byzantine, sixth century C.E. (Detail of Procession of Female Saints, mosaic from Sant' Apollinare Nuovo, Ravenna, Italy.)

B. Roman, second century B.C.E. to second century C.E. (*Judgment of Paris*, fresco from Pompeii, first century B.C.E. National Museum, Naples.)

These two works illustrate the change from Roman illusionism (as seen at Pompeii) to the more abstract and symbolic style that was to develop through Early Christian art into the Early Byzantine style. Even from the black-and-white reproductions, you should be able to distinguish between the media of the two works—the fresco technique, which was do commonly used by the Romans for wall decorations, and the glistening mosaic preferred by the Christian artists of the sixth century working at Ravenna. Although the media contributed to a certain degree to the style seen in the two works—the quick, painterly brush strokes adding to the illusionism of the Roman example and the glass chips of the mosaic emphasizing the flat, otherworldly quality of the frieze—the artists manipulated the media to produce the effects favored by their respective cultures. To achieve the illusion of the world in which we live is of obvious interest to the Roman artist; his figures are placed to emphasize their existence in three-dimensional space and modeled in the round with rapid, painterly strokes to heighten a sense of their reality. The Early Christian/Byzantine artist, on the other hand, uses formal means to minimize real space and to set his figures in a transcendental world. Instead of overlapping his figures as the Roman artist had done, he places them in a line, separating them from each other by date palms, and thus creates a rhythmically repeated pattern. The heads and feet all extend to the same level, and the ground on which they stand seems to be tilted upward. As in other sixth-century mosaics, like the *Miracle of the Loaves and Fishes* in Sant' Apollinare Nuovo, the artist tells his story in terms of an array of symbols, lined up side by side. The details of costume and trees create a right tapestry design, although the figures retain hints of the three-dimensional modeling that characterized the Roman style and which would be lost in many subsequent Byzantine works. However, the flat background keeps us from confusing our world with theirs; they abide solely on another plane of reality.

ESSAYS
Answers found throughout the text.

PREPARING FOR YOUR EXAMINATIONS

As you prepare to take your examination you should review the notes you took on your lectures as well as the work you did in your Study Guide. (Look back at the **Introduction to the Study Guide** for tips on taking notes and creating your own charts, as well as detailed instructions on studying for and taking examinations.) If you have not yet filled out the Summary charts in the Guide, this is the time to do it, integrating materials from your lecture notes with materials in the Guide itself. This activity is the most useful thing that you can do.

The self-quiz included below, as well as the materials included in the **Companion Site** for the textbook, can be a great help in preparing you for course examinations. The questions are modeled on those commonly asked on art history examinations: multiple choice, short answer questions, chronology exercises, essay questions and attribution of unknown images.-Take the self-quiz and check your answers in the back of the book; see how well you grasp the material. If you are unclear about certain areas review the text and utilize the on-line Web Site and WebTutor tools to fill in the gaps. You may also wish to consult the WorldImages website which contains many art historical images and is the source of the images used in the quiz below. See http://worldimages.sjsu.edu. Note particularly the Art History survey section.

Self-Quiz
THE MIDDLE AGES

CHAPTERS 12, 13, 16, 17, 18

MULTIPLE CHOICE
Circle the most appropriate answer.

1. A trumeau would most likely be found:

 a. on an Ionic temple
 b. as part of the doorway of a Medieval church
 c, in a Gothic wall elevation above the arcade
 d. in an Ottonian alternating support system

2. Many of the finest Islamic manuscripts were created for the rulers of:

 a. Spain b. Egypt c. Iran d. Arabia

3. The domed structure of Saint Mark's in Venice is closest to :

 a. Hagia Sophia in Constantinople b. the mirab of the Great Mosque
 in Cordoba
 c. St. Michael's Hildesheim d. Canterbury Cathedral

4. The west tympanum of Saint Lazare at Autun contains an illustration of:

 a. the Last Supper b. Christ in Majesty with Angles and 24 Elders
 c. the Last Judgment d. the Madonna holding the Christ Child

5. During the Carolingian period, Reims was most famous for its:

 a. manuscripts b. mosaic decoration c. interlace carving d. sarcophagi

6. A Gothic church is often distinguished from an Early Christian basilica by its:

 a. transepts b. nave and aisles c. baysd. clerestory

7. Monumental sculpture first appeared on the facades of churches in:

 a. sixth/seventh-century Italy b. eighth-century England
 c. ninth-century Spain d. eleventh/twelfth-century France

8. A squinch would most likely be found:

 a. as part of a column b. supporting a dome
 c. guarding a harem d. supporting the carved lintel of a façade

9. Triforium is the term used to describe:

 a. the area where the nave intersects the transept
 b. the arch thrown across a barrel vault from one pier to the next
 c. an anteroom where sacred vestments are kept
 d. a blind arcade below the clerestory in a gothic wall elevation

10. The important patron who was portrayed at San Vitale in Ravenna was:

 a. Constantine b. Justinian c. Mohammed d. Athanasius

11. Large stained-glass windows would most likely be found in association with:

 a. domes set on pendentives b. barrel vaults
 c. pointed rib vaults and flying buttresses d. corbelled vaults

12. The earliest jamb or column statues are found on the west portal of:

 a. St. Michael's at Hildesheim b. St Pierre at Moissac
 c. Amiens Cathedral d. Chartres Cathedral

13. Which feature is NOT a characteristic of the Great Mosque at Cordoba:

 a. hypostyle prayer hall b. an elaborate dome in front of the mirhab
 c. a chevet with ambulatory d. horseshoe and multilobed arches

14. The Gothic style of architecture developed in the region that is called:

 a. the Rhineland, Germany b. Normandy, France
 c. Tuscany, Italy d. Ile-de-France, France

15. Which element of Gothic architecture is not found in at least one Romanesque example?

 a. pointed arch b. rib vault c. towers d. flying buttresses

16. Sutton Hoo is famous:

 a. as the site of a ship burial b. for its magnificent twelfth-century cathedral
 c. as the site of a famous battle d. for its production of Medieval manuscripts

17. Sinan is most famous for:

 a. the sculpture of Modena b. his central-plan mosques
 c. his painted icons d. his luxurious rugs woven for the Shah

18. The iconoclast controversy rocked the Byzantine world during the:

 a. 2nd-4th centuries b. 5th-6th centuries
 c. 8th-9th centuries d. 11th-12th centuries

19. The structure of the mosque of Selim II was strongly influenced by that of:

a. Sant' Apollinaire in Ravenna b. Hagia Sophia
c. Amiens Cathedral d. the Great Mosque at Mecca

20. A sexpartite rib vault was typical of buildings in which style?

a. Romanesque b. Early Gothic c. High Gothic d. Ottonian

21. The sculptures of the typmpanum at Moissac represent:

a. Christ in Majesty with Angles and 24 Elders b. the Last Judgement
c. the Mission of the Apostles d. the Life of the Virgin

22. The windowed section of the nave wall above the aisle roofs is called the:

a. clerestory b. gallery c. triforium d. trumeau

23. The square east end is a distinguishing feature of the cathedral of:

a. St. Michael's Hildesheim b. Chartres Cathedral
c. Salisbury cathedral d. Amiens Cathedral

24. One of the most beautiful Byzantine manuscripts of the 10th century, the so-called "Macedonian Renaissance" was the:

a. *Rabbula Gospels* b. *Paris Psalter*
c. *Vatican Virgil* d. *Psalter of Archbishop Ebbo*

25. The primary medium used to decorate the apse of the church of Santa Maria de Mur and the vault of Saint-Savin-sur-Gartemps was:

a. mosaic b. sculpture c. fresco d. gold and enamel

26. The art of stained glass was most highly developed during which period?

a. Carolingian b. Ottonian c. Romanesque d. Gothic

27. The greatest tendency toward realism is seen in :

 a. the tympanum of Saint-Lazare at Autun
 b. the figures from the Porch of the Confessors at Chartres Cathedral
 c. the Visitation group at Reims Cathedral
 d. Ekkehard and Uta from Naumburg Cathedral

28. Which of the following is a hall church?

 a. Orvieto Cathedral b. Saint Sernin at Toulouse
 c. Saint Elizabeth at Marburg d. Salisbury Cathedral

29. Which of the following was/were highly developed in Islamic countries?

 a. tile work b. textiles c. mural decoration d. both a & b

30. Maqarnas would most likely be found :

 a. in a Hiberno-Saxon manuscript b. on a Romanesque portal
 c. on a Gothic antependium d. on an Islamic arch

31 A,B,C&D

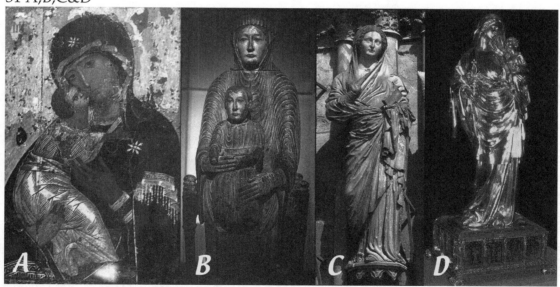

31. The style of the image shown on 31A is:

 a. Carolingian b. Byzantine c. Romanesque d. Gothic

32. The style of the image shown on 31B is:

 a. Carolingian b. Byzantine c. Romanesque d. Gothic

33. The image shown on 31B was created in which period:

 a. 6th-7th c b. 8th-9th c c. 11th-12th c d. 13th-14th c

34. The style of the image shown on 31C is:

 a. Carolingian b. Byzantine c. Romanesque d. Gothic

35. The image shown on 31B was placed on a building in which city?

 a. Chartres b. Amiens c. Reims d. Cologne

36. Which art works were done in France?

 a. A and B b. A and C c. A and D d. B, C and D

37. The image shown on 31D was created in which period:

 a. 6th-7th c b. 8th-9th c c. 11th-12th c d. 13th-14th c

38A&B

38. The building shown in 38A was built in:

 a. Aachen b. Constantinople c. Jerusalem d. Cologne

39. The building shown in 38A was constructed on the orders of:

a. Constantine b. St. Bernard c. Justinian d. King Louis

40. The building shown in 38B was built in:

a. Damascus b. Constantinople c. Jerusalem d. Isfahan

41. Which is NOT true of the building shown in 38B?

a. It is shaped as an octagon topped by a dome.
b. It is said to have been built on command of Mohammed himself.
c. Mohammed is said to have left from here on his night flight to heaven.
d. It's original tiles are preserved on the interior of the dome.

42A,B,C&D

42. The figure shown on 42A can be described as

a. Roman victory figure b. St. Michael c. St Matthew d. a diptych

43. The object shown on 42B is:

a. a fibula b. a maqarnas c. Migration period d. A and C

44. The object on 42C is typically:

a. Byzantine b. Hiberno Saxon c. Romanesque d. Gothic

45. The style of the object on 42D is typically:

 a. Ottonian b. Islamic c. Hiberno Saxon d. Decorated Gothic

46A,B,C&D

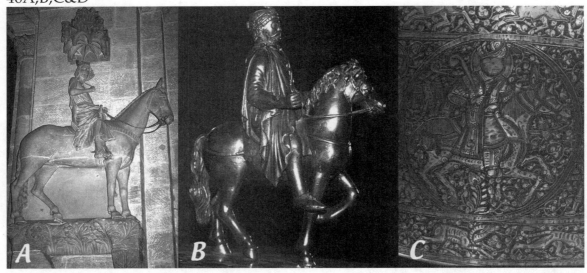

46. The style of the image shown on 46A is:

 a. Carolingian b. Byzantine c. Ottonian d. Gothic

47. The image shown on 46A was carved in:

 a. Germany b. France c. England d. Italy

48. The person represented on 46B was:

 a. Ibn ben Jusuf b. King Henry II c. Charlemange d. Justinian

49. The figure shown on 48B was created during which period?

 a. 6th-7th c b. 8th-9th c c. 11th-12th c d. 14th-15th c

50. The style of the image shown on 46C is:

 a. Islamic b. Byzantine c. Romanesque d. Gothic

CHRONOLOGY EXERCISE
Put the letters corresponding to specific art works under the appropriate date range:

51. *Lindisfarne Gospels*
52. *Utrecht Psalter*
53. *Bayeux Tapestry*
54. Great Mosque, Kairouan, Tunisia
55. *Bury Bible*
56. Purse from Sutton Hoo burial
57. *Ekehard and Uta*
58. *Psalter of Saint Louis*
59. Frankish fibula
60. Laon Cathedral
61. Villard de Honnecourt notebook
62. *Gospel Book of Otto III*
63. Bamberg Rider
64. *The Virgin of Paris*
65. Visitation, Reims Cathedral
66. Prophet from Saint-Pierre, Mossaic
67. Great Mosque, Damascus
68. San Miniato al Monte
69. Gloucester Cathedral
70. Doors of Saint Michael, Hildesheim
71. Dome of the Rock, Jerusalem
72. Chapel of Henry VII, Westminster
73. Plan of Saint Gall
74. Sainte-Chapelle, Paris
75. Virgin (Theotokos) & Child icon (Vladimir Virgin).
76. Mss. of *Shahnama of Shah Tahmasp*, Iran
77. Theodore, Porch of the Martyrs, Chartres
78. San Vitale, Ravenna
79. Amiens Cathedral
80. Rublev, *Old Testament Trinity*

a. 5th-8th centuries
b. 9th-10th centuries
c. 11th-12th centuries
d. 13th-16th centuries

SHORT ANSWER QUESTIONS
Answer the question or finish the sentence.

81. What and where is the Alhambra?

82. Why do human figures not appear in the decoration of mosques?

83. What is a caravansary?

84.What is the meaning of the Anastasis?

85. Name two buildings associated with Justinian:

86. Who was Andre Rublev and what kind of work did he do?

87. What is an iconostatis and what function did it serve?

88. What building was designed and constructed by Anthemius of Tralles and Isidorus of Miletus.? Briefly describe it.

89. Name the four evangelists and indicate their symbols:

90. What is the significance of the quibla wall?

91. What is a codex?

92. What was an ambulatory and what was its purpose?

93. Who was Mohammed?

94. The church of San Vitale in Ravenna is thought to have served as model for Charlemagne's :

95. Name two Hiberno-Saxon manuscripts and briefly indicate the type of decoration that was used to illustrate them.

96. The eight/ninth century European ruler who encouraged the revival of classical learning and art forms was:

97. What is a fibula?

98. What kind of a vault is created by the intersection of two barrel vaults?

99. What art work portrayed the Battle of Hastings showing the Norman conquest of England?

100. Who was responsible for the bronze doors on the church of Saint Michael's at Hildsheim and what did they portray?

101A,B,C&D

101. Which images of Christ were done in Germany?

102. The style of the image shown on 101A is:

103. Name the city and the country where the figure on 101A was made.

104. What is the image shown of 101C called?

105. What is represented in the image shown on 101D:

106. The style of the image shown on 101D is:

107. Put the images on 101A-D in chronological order.

108. Which do you like best?
 Briefly say why you like it best.

109 A,B,C&D

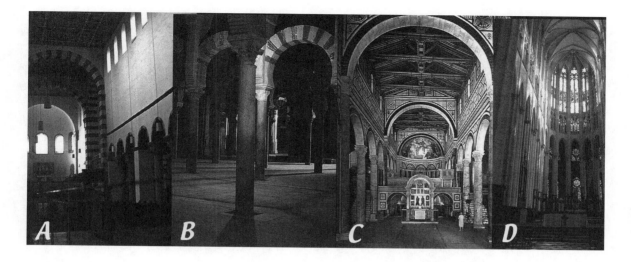

109. Which interior was done in the Ottonian style?

What features mark it as Ottonian?

110. Name the style of the image shown on 109B.

 What feature identifies it as such?

111. What is the name of the building shown on 109C and where is it located?

112. Name the style of the image shown on 109D.

What feature identifies it as such?

113A,B&C

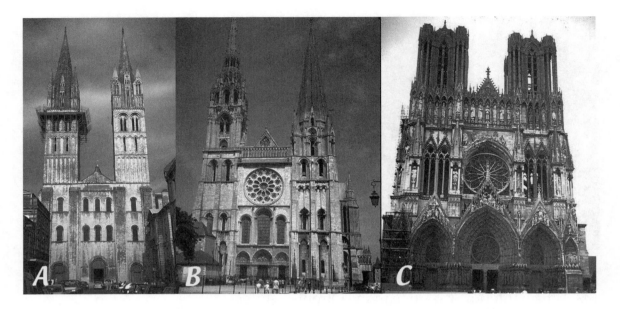

A B C

113. Name the style of the image shown on 114A and give the century in which it was built.

114. Name the style of the image shown on 114B and give the name of the building.

115. Name the style of the image shown on 114C; give the name of the building and the century in which it was built.

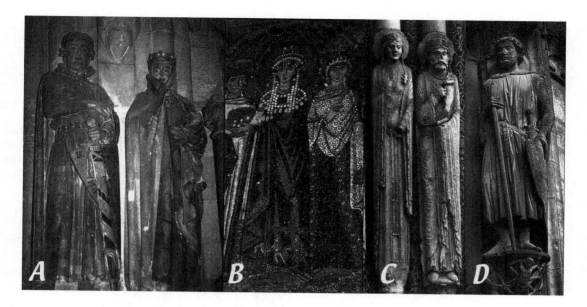

116. Put the four images in chronological order.

117. Who is portrayed in 116B and where is the portrait?

118. In what country and in what century were the figures in 116A created? What was their role in the building where they are found?

119. What is the location of the figures in 116C and what are they called?

120. The figure sown on 116D is found on the same building as those in 116C and yet is very different. Describe the differences.

ANALYSIS OF UNKNOWN IMAGES

121. Compare the two sculptures below, attributing each to a particular period
and providing an approximate date. Give the reasons for your attributions.

A. Period:

 Date:

 Reasons:

B. Period:

 Date:

 Reasons:

122. In what period, style, and century was the church below erected? To what group of churches is it related? What features demonstrate this relationship?

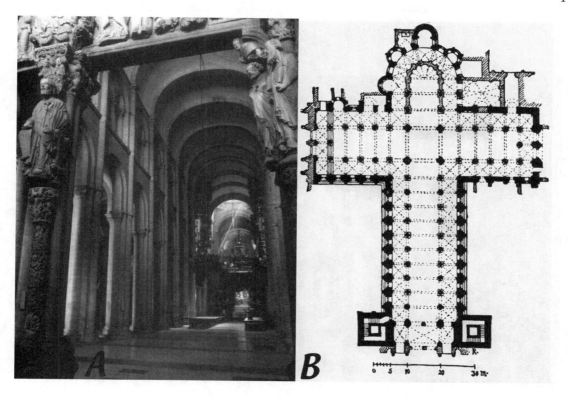

Period:

Style:

Century:

Group:

Features:

123. Label as many parts of the medieval church illustrated below as you can. Identify and date the building. It contains features of two architectural styles: what are they? Also, describe the architectural features that are characteristic of each style used in this building.

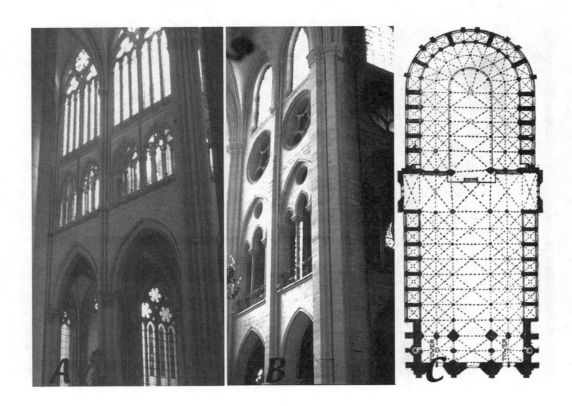

Identity:

Date:

Styles:
 a. b.

Features:

124. The mosque below was influenced by a famous Christian building. Describe the earlier building, noting when and where it was built. What architectural features do they have in common? When and where might this building have been built? How do you know that this building is Islamic and not Christian?

Identity of earlier building:

 Date:

 Location:

Common Features:

Date:

Location:

Features:

Reasons:

125. Compare the two works below, attributing each to a culture and providing an approximate date. Give the reasons for your attributions.

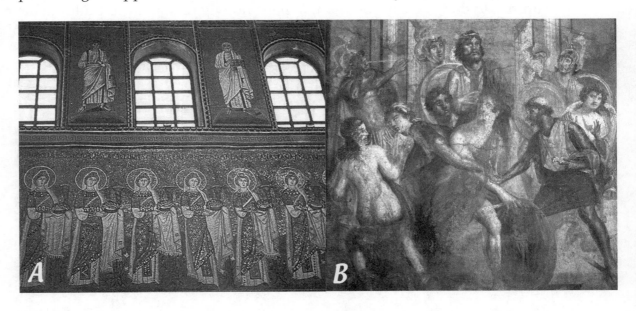

A. Culture:

 Date:

 Reasons:

B. Culture:

 Date:

 Reasons:

ESSAYS

Select one essay, and be sure and cite specific examples to illustrate your argument.

A. How did the representations of Christ change from Early Christian times to the end of the Gothic period? Consider representations in an early catacomb fresco (FIG. 11-5), in San Vitale (FIG. 12-9), at Daphne (FIG. 12-1), at Moissac (FIG. 17-1), the Beau Dieu from Amiens (FIG. 18-22), and the Gothic Pieta (FIG. 18-51). What historical factors do you think might have contributed to these different representations?

B. Discuss the development of Medieval architecture in Northern Europe from the Carolingian through the Gothic period. Select at least four buildings to illustrate your argument.

C. Describe two types of mosques, comparing their structure and noting influences from Roman and/or Christian buildings.

QUIZ ANSWERS
MIDDLE AGES

MULTIPLE CHOICE

1. b 2. c 3. a 4. b 5. a 6. c 7. d 8. b 9. d 10. c 11. c 12. d
13. c 14. e 15. d 16. a 17. b 18. c 19. e 20. b 21. b 22. a 23. c 24. b
25. c 26. e 27. e 28. c 29. b 30. d 31. b 32. c 33. c 34. d 35. c 36. d
37. d 38. b 39. c 40. c 41. b 42. b 43. d 44. c 45. b 46. d 47. a 48. c
49. b 50. a

CHRONOLOGY

51. a 52. b 53. c 54. b 55. c 56. a 57. d 58. d 59. a 60. d 61. d 62. b
63. d 64. d 65. d 66. c 67. a 68. c 69. d 70. c 71. a 72. d 73. b 74. d
75. c 76. d 77. d 78. a 79. d 80. d

SHORT ANSWERS

81. A fourteenth-century Islamic palace in Granada , Spain.

82. Islam forbids "graven images" that might be worshipped.

83. A fortified building that provided shelter and protection for traders and their animals.

84. Between the death of Christ and his resurrection he descended into Limbo to free the faithful who had died before his coming.

85. San Vitale in Ravenna and Hagia Sophia in Constantinople (Istanbul).

86. Rublev was a Russian icon painter

87. A large screen that holds icon paintings and which shuts off the sanctuary of a Byzantine church from the rest of the building.

88. Hagia Sophia in Constantinople (Istanbul) what a large church that combined a long basilica type plan with a central structure, using a central dome supported by two half domes.

89. Matthew (winged man), Mark (winged lion), Luke (winged bull) and John (eagle).

90. It indicated the direction toward Mecca so that people could pray facng the correct direction.

91. A book consisting of groups of pages bound together, the predecessor of the modern book. It replaced scrolls.

92. A passage around the apse of a church, developed for use by pilgrims to visit holy relics without disturbing the monks.

93. The founder of Islam, the religion of the Muslims.

94. The Palace or Palatine Chapel in Aachen

95. Two out of three: the Lindesfarne gospels, the book of Durrow, and the book of Kells. They were decorated with abstract and often interlaced designs.

96, Charlemagne.

97. A decorative pin, usually used to fasten garments.

98. A groin vault.

99. The Bayeux Tapestry

100. Abbot Bernward of Hildesheim. The doors portrayed scenes from the Old and New Testaments.

101. B and C

102. Gothic

103. Amiens. France.

104. Pieta. It shows Mary holding the dead Christ.

105. Christ in Majesty with the symbols of the four evangelists.
106. Romanesque

107. B D A C

108. Any answer is appropriate.

109. A. The alternating support system seen on the wall with column, pier, pier, column was developed in Ottonian Germany. The wooden roof is also typical as is the marked crossing square which forms the module used in the alternating support system. Although the wall is subdivided, the divisions do no yet go up the wall.

110. The building is Islamic with a large prayer-hall with many columns. The horseshoe arches are the most obvious mark of its Islamic origin.

111. San Miniato al Monte in Florence Italy.

112. The immense height of the building and its large windows mark it as Late Gothic. The skeletal structure with its pointed arches and rib vaults supported by flying buttresses make both possible.

113. Romanesque. 12th century Norman.

114. Chartres Cathedral. Early Gothic façade with later towers.

115. High Gothic; Reims cathedral; 13th century.

116. B C D A

117. Theodora, Byzantine Empress, I portrayed in the church of San Vitale in Ravenna.

118. The nobles Ekkehard and Uta were carved in Germany in the 13th century. They were patrons of the church and are portrayed in the choir.

119. The figures are on the jambs of the west portal of Chartres Cathedral. The are known as column figures and are sometimes identified as the ancestors of Christ.

120. The figure of the knight, on the south porch of Chartres Cathedral, was carved approximately 80 years later than the column figures on the west portal. His proportions are much more realistic than those of the column figures. He stands in a natural fashion and sees to be freed from the column rather than being an integral part of it.

ANALYSIS OF UNKNOWN IMAGES

In each of the answers to the analysis questions, the first date provided is the range within you should have dated the work, the second date — in parenthesis — is the actual date accepted by scholars.

121. A. Romanesque, twelfth century (*Prophet Isaiah*, from the portal of the church of Souillac, Lot, France, C. 1130-1140.)

B. Gothic, thirteenth to fourteenth centuries (*Virgin*, from the north transept, Nortre-Dame, Paris, second half of the thirteenth century.)

These two figures demonstrate some of the changes that took place in French monumental sculpture between the Romanesque and Gothic periods. The elegant prophet with his elongated body and decorative drapery resembles many Romanesque figures from southern France. The incised linear detail, the swinging drapery folds, and the cross-legged, almost dancing pose show a close relationship to the Jeremiah carved on the trumeau of St.-Pierre at Moissac (fig 17-24). In both cases, the artist seems to be using the forms of the body and drapery to express the mystic inner state of his figures rather than to describe their physical presence. The low relief of the Romanesque figures has given way in the Gothic statue to a body carved much more fully in the round, and a trance-like ecstasy of the Romanesque prophet has been transformed into the fully ripened corporality of the Gothic style. Like the figures in the Reims portal (fig. 18-22), the drapery of the Virgin is heavy, falling in massive folds quite different from the delicate arabesques of the Romanesque drapery. The Virgin demonstrates the Gothic concern for more natural proportions of the body; however, this naturalism is blended with a kind of Classical calm and monumentality seen in many High Gothic figures. The graceful swing of the drapery shows hints of the mannered elegance that began with Reims and continued in fourteenth-century Gothic figures like *The Virgin of Paris* (fig.18-24), as does the upward tilt of the hips, which gives this figure a typical Gothic S-curve.

122. Romanesque, Cluniac-Burgundian, principally twelfth century (Santiago de Compostela, Spain, 1077-1211).

Both the plan and elevation of this Romanesque church bear a strong resemblance to the church of Saint-Sernin at Toulouse (figs 17-4 – 17-6) and this is one of the churches that were built along the pilgrimage road in southern France and northwestern Spain. This particular church marked the site that was the goal of the pilgrimage. Many of the churches along this road were built in the Cluniac-Burgundian style, a style characterized by semicircular stone vaults, a square crossing, extreme regularity and precision, and an ambulatory with radiating chapels. As in the church of Saint-Sernin, the square crossing of this church is used as a module for the rest of the building, with each nave bay measuring exactly one-half and each aisle square measuring exactly one-fourth of the crossing square. The floor plan is carried up the walls by the attached columns that mark the edges of each bay and then over the vault by the transverse arches. The wall elevation, like that of Saint-Sernin, is marked by aisle arcades surmounted by tribunes. The heavy masonry vaults in both cases preclude the creation of a clerestory, thus creating dark interiors. The aisles are covered by groin vaults, but while Saint-Sernin has a double row of aisles, this church has only one. It does, however, have the same type of ambulatory with radiating chapels, a feature that was particularly popular in the pilgrimage churches, since it permitted the pilgrims to view the relics without disrupting the monastic services. While this building shares the clear articulation and segmentation of space that characterize Gothic churches, the round arches, the lack of rib vaulting as well as the lack of a clerestory, and the use of a gallery rather than a triforium mark it as Romanesque.

123. Notre-Dame, Paris, late twelfth to mid-thirteenth century (1163-1250), Early and High Gothic styles. Check the accuracy of your identification of the various parts of the building using the diagrams below.

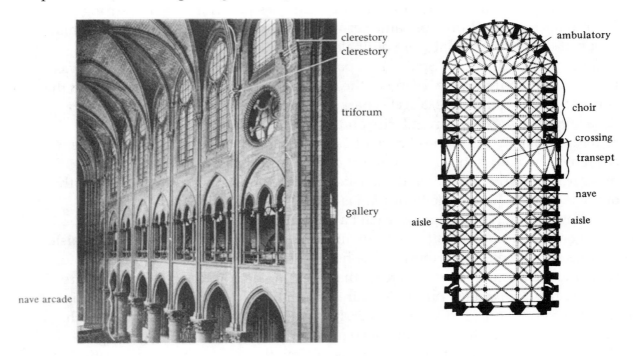

The illustration shows clearly the transition from Early to High Gothic architecture, as described in the test. Most significant is the change in the nave-wall elevation from a quadripartite elevation to a tripartite elevation. The four parts of an Early Gothic elevation—nave arcade, gallery, triforium, and clerestory—seen in the right bay were changed in the other bays of the nave to a tripartite elevation by merging the two upper windows to allow more light to penetrate the nave. The retention of the gallery in the tripartite elevation shows this to be a modification of Early Gothic rather than a true High Gothic elevation, which typically consists of a nave arcade, triforium, and clerestory. The six-part vault system used in the nave is typical of Early Gothic buildings, but the alternate-support system used in Early Gothic churches has been abandoned.

124. The architect of this building was strongly influenced by the Early Byzantine church of Hagia Sophia that was built in Constantinople in the sixth century. Like Hagia Sophia this building is dominated by a large central dome, which is buttressed by supporting half domes and a series of smaller domes. The four minarets mark the building as Islamic rather than Christian. This building could have been constructed in Turkey in the sixteenth century for it strongly suggests the style of the Ottoman architect Sinan the Great. It closely resembles the Selimiye Cami that he erected in Eridne, Turkey, in the early sixteenth century, demonstrating the same combination of a domed centralized structure with flanking minarets.

125. A. Hiberno-Saxon, sixth to ninth centuries C.E. (*Matthew the Evangelist*, from the *Book of Darrow*, seventh century C.E. Trinity College, Dublin.)

 B. Carolingian, eighth to ninth centuries C.E. (*John the Evangelist*, from the *Gospel Book of Archbishop Ebbo of Reims*, c. 816-835. Bibliotheque Nationale, Paris.)

 These two evangelist pages illustrate two very different approaches to form that were used by artists working in the Early Middle Ages. Illustration A is typical of the fusion of Germanic and Celtic styles found in Hiberno-Saxon manuscripts. The artist was not in the least concerned with illusionism, but instead created a style that was abstract, decorative, and (except for the figure's feet) bilaterally symmetrical. The flat form of the body with its complex inlay patterns is closely related to the jewelry forms created by Germanic craftsmen, while the spirals around the frame reflect the complicated interlace so popular with Celtic artists. The entire page decoration is flat and linear, and there is no interest whatsoever in three-dimensional form. The artist who created the Evangelist from the Ebbo Gospels, however, was very much interested in creating the illusion of three-dimensional form and undoubtedly based the drawing on prototypes that were derived from the illusionistic, Late Antique style, a practice encouraged by the emperor Charlemagne. The strange perspective of the writing desk and stool indicate that the Carolingian artist did not fully understand the spatial illusionism of the model. Yet the overall linear technique of this northern artist has given a new vitality to the old models, The nervous, spontaneous line of the tense energetic figure is closely related to the other illuminations produced by artists of the Reims School in the first half of the ninth century.

ESSAYS
Answers found throughout the text.

PREPARING FOR YOUR EXAMINATIONS

As you prepare to take your examination you should review the notes you took on your lectures as well as the work you did in your Study Guide. (Look back at the **Introduction to the Study Guide** for tips on taking notes and creating your own charts, as well as detailed instructions on studying for and taking examinations.) If you have not yet filled out the Summary charts in the Guide, this is the time to do it, integrating materials from your lecture notes with materials in the Guide itself. This activity is the most useful thing that you can do.

The self-quiz included below, as well as the materials included in the **Companion Site** for the textbook, can be a great help in preparing you for course examinations. The questions are modeled on those commonly asked on art history examinations: multiple choice, short answer questions, chronology exercises, essay questions and attribution of unknown images.-Take the self-quiz and check your answers in the back of the book; see how well you grasp the material. If you are unclear about certain areas review the text and utilize the on-line Web Site and WebTutor tools to fill in the gaps. You may also wish to consult the WorldImages website which contains many art historical images and is the source of the images used in the quiz below. See http://worldimages.sjsu.edu. Note particularly the Art History survey section.

Self-Quiz
THE WORLD BEYOND EUROPE

CHAPTERS 6, 7, 8, 14, 15

MULTIPLE CHOICE
Circle the most appropriate answer.

1. Earthenware portrait jars with stirrup spouts were the most famous works produced by the:

 a. Olmec b. Hopi c. Moche d. Maya

2. Buddhism entered China in the period known as:

 a. Shang b. Chou c. Han d. Sung

3. One of the most important early Buddhist shrines, the Great Stupa, is located at:

 a. Sanchi b. Ajanta c. Khajuraho d. Dunhuang

4. The Shang period is most famous for its:

 a. painted scrolls b. bronze vessels
 c. jade burial suits d. representations of the Buddha

5. Important cliff dwells were found at:

 a. La Venta b. Mesa Verde c. Tlingit d. Teotihuacan

6. An important Maya site was:

 a. Teotihuacan b. Cuzco c. Quito d. Tikal

7. During the Heian period a new type of image was brought into Japan that:

 a. was very delicate with graceful folds
 b. was decorated with complicated interlace patterns
 c. was heavier with multiple arms
 d. was markedly realistic

8. An important site in the early Indus Valley Civilization was:
 a. Mohenjo-Daro b. Sanchi c. Borobudur d. Ajanta

9. Sixth-century Chinese artistic representations created under the influence of the Buddhist Pure Land sects, in contrast to those done for the esoteric sects, tended to stress:

 a. more complex symbolism b. strange, awkward postures
 c. increasing naturalism and grace d. stiffer, formal compositions

10. The artistic traditions of Greece and Rome influenced those of Buddhism through contact in the region of:

 a. Karli b. Sanchi c. Gandhara d. Elephanta

11. One of the most important Buddhist monuments of Southeast Asia was erected in the eighth century at:

a. Borobudur b. Bali c. Sanchi d. Angkor Thom

12. The shrines of Angkor Wat and Angkor Thom are located in:

a. Thailand b. Cambodia c. Sri Lanka d. Burma (Myanmar)

13. A triple-headed image of Shiva as the incarnation of the forces of creation, preservation and destruction is important in the religious tradition of:

a. Zen Buddhism b. Esoteric Buddhism c. Shinto d. Hinduism

14. One of the earliest Buddhist temples in Japan was constructed during the seventh century near Nara and is known as the:

a. Yunkang b. Ise shrine c. Toyokuni shrine d. Horyuji

15. The murals at the Ajanta caves provide a glimpse of early Indian painting. The bodhisattva painted in one of them is typical of their style that is characterized by:

a. grace and delicacy b. strong emotion and motion
c. exaggerated realism and power d. clarity, dignity and serenity

16. An artistic form during the Jomon period was the creation of:

a. clay haniwa figures b. Buddhist images with many arms
c. painted handscrolls d. bronze vessels

17. An important Chinese painter was:

a. Sesshu b. Manitoba c. Fan Kuan d. Genji

18. The pre-Columbian peoples of West Mexico from the areas of Jalisco, Colima and Nayarit are most famous for their:

a. stone carving b. earth mounds
c. ceramic sculpture d. stone pyramids

19. Which of the following features was LEAST typical of Maya architecture?

a. flying facades
c. corbelled vaults
b. roof combs
d. flying buttresses

20. Which of the following was NOT a Pre-Columbian group from South America or Mesoamerica?

a. Haniwa b. Moche c. Olmec d. Maya

21. Fine bronze work was done by a group known as the:

a. Dogon b. Benin c. Nok d. Baga

22. A large mount approximately 1,400 feet long, known as the Serpent Mound, was constructed by the inhabitants of the:

a. American southwest
c. Northwest Coast
b. Woodlands region above the Ohio river
d. Plains region

23. Some of the most realistic representations in African art were done of the kings of:

a. Nok b. Dan c. Tassili d. Ife

24. Some beautiful Maya murals were found at:

a. Teotihuacan b. Tikal c. Bonampak d. Tenochtitlan

25. Quetzalcoatl was:

a. an Inca prince
b. the model for the giant head found at La Venta
c. author of the Popol Vuh
d. a Mesoamerican deity depicted as a feathered serpent

26. The first emperor of China who built a magnificent tomb for himself was:

a. Kublai Khan b. Kuan-yin c. Shi Huangdi d. Lungmen

27. It could be said that Chinese painting demonstrates:

 a. the ceaseless and random movements of nature
 b. the infinity of cosmic happenings
 c. the smallness of human beings in nature
 d. all of the above

28. A Buddhist tower with multiple winged eves is known as a:

 a. stupa b. chaitya c. pagoda d. guang

29. Typical of artworks inspired by Chan beliefs are:

 a. quick spontaneous brush stokes
 b. carefully detailed renderings of natural objects
 c. depictions of deities using rich luxurious materials
 d. deities depicted with multiple arms

30. Among the oldest paintings of animals are those found in:

 a. Africa b. China c. India d. South America

31A,B&C

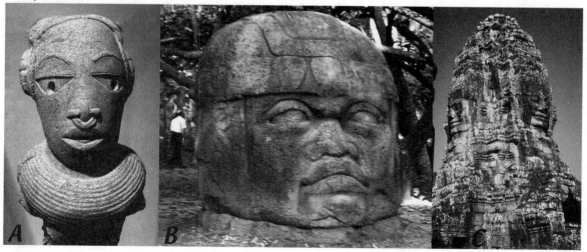

31. The head shown in figure 31A was created by the people known as the:

 a. Khmer b. Nok c. Dogon d. Sapi

32. The head shown in figure 31B was created by the people known as the:

 a. Olmec b. Maya c. Mississipian d. Toltec

33. The head shown in figure 31B was created in:

 a. Mexico b. Cambodia c. Africa d. Guatemala

34. The head shown in figure 31C was created in:

 a. Mexico b. Cambodia c. Africa d. Guatemala

35. Which of the heads in Fig. 31 was (were) made of ceramic?

 a. A b. B c. C d. Both A and C

36A,B&C

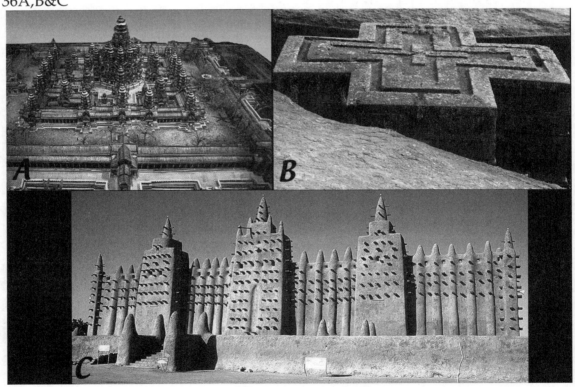

36. The building shown on 36A is a model of:

 a. Angkor Wat b. Nara c. Shanaaxi d. Teotihuacan

37. The religion practiced in the building shown on 36A was:

 a. Christianity b. Islam c. Hinduism d. Shinto

38. The location of the building shown on 36B is:

 a. Ethiopia b. Mali c. Cambodia d. Nigeria

39. The religion practiced in the building shown on 36B was:

 a. Christianity b. Islam c. Hinduism d. Shinto

40. The location of the building shown on 36C is:

 a. Ethiopia b. Mali c. Cambodia d. Timbuktu

41. The religion practiced in the building shown on 36C was:

 a. Christianity b. Islam c. Hinduism d. Shinto

42A,B&C

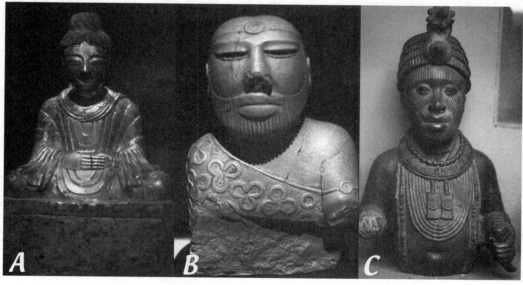

42. The figure shown on 42A is:

 a. a Buddha from Gandhara b. a representation of Harihara
 c. a Japanese monk d. the earliest Buddha in China

43. The figure shown on 42B is from the:

 a. Buddhist culture of Gandhara b. Indus Valley Civilization
 c. Khmer culture of Cambodia d. Hindu culture of Timbuktu

44. The figure shown on 42C is represents:

 a. a Khmer priest-king b. an Ife king from Nigeria
 c. a priest from Lalibela d. a Nok ruler from Mali

45A,B&C

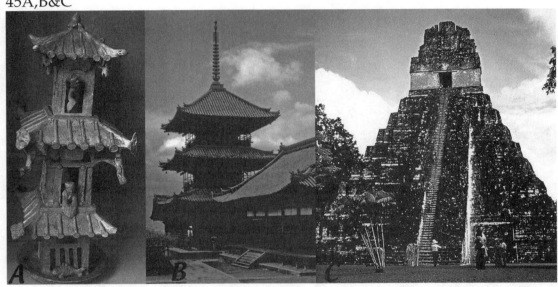

45. The object shown in 45A is the representation of a:

 a. Japanese temple b. Han watchtower
 c. Khmer royal guardhouse c. Friday mosque

46. The building represented on 45B is a:

 a. Japanese temple b. Han watchtower
 c. Khmer royal guardhouse c. Indus Valley palace

47. The building represented on 45C is:

 a. an Egyptian pyramid b. a Mesopotamian ziggurat
 c. a Mayan pyramid d. a pyramid at Timbuktu

48. The building represented on 45C:

 a. served as a platform for ceremonies b. was constructed by the Ife
 c. is an important Precolumbian site d. Both A and C

MATCHING

Choose the identification in the right column that best corresponds to the term or name in the left column and write the appropriate letter in the space provided.

_____49. sutra a. Buddha of the Pure Land Sect

_____50. mandala b. a sermon or dialogue involving the Buddha

_____51. stupa c. large mound-shaped Buddhist shrine

_____52. Amitabha d. a person who is a potential Buddha

_____53. Siddhartha e. Japanese horizontal scroll

_____54. Copan f. Eskimo ceremonial object

_____55. bodhisattva g. a magical, geometric symbol of the cosmos

_____56. ushnisha h. the man who became Buddha Sakyamuni

_____57. haniwa i. protuberance on the Buddha's forehead

_____58. Mimbras j. cultural group from New Mexico

_____59. stele k. African group known for its realistic sculptures

_____60. Chavin l. Buddhist assembly hall

_____61. Ife m. carved stone slab or pillar, often used as a marker

_____62. chaitya n. circular ceremonial center in a pueblo

_____63. Oba o. Japanese figures used on tombs

 p. title of Benin hereditary king

 q. early pre-Columbian group in Peru

 r. important Mayan site

SHORT ANSWER QUESTIONS
Write the answer that best completes the sentence or answers the question.

64. Beautiful bronze ritual vessels were the most characteristic artistic expression of which Chinese Dynasty? For what were they used?

65. Name one factor that contributed to the popularity of the Pure Land Sect of Buddhism.

66. Name the sixth century BCE Chinese philosopher who stressed the virtues of family governmental service.

67. Name two Chinese dynasties that are well known for their ceramic tomb figures and list common types of figures they created.

68. What was the *Tale of Genji* and from what culture did it come?

69. Name the group that created the first sub-Saharan ceramics.

70. During the fifteenth and sixteenth centuries a series of ivory salt-cellars of mixed European/African style were created by Sapi artists working for the _____.

71. The ruins of Great Zimbabwe are located in _____. What is thought to have been its purpose?

72. What is a kiva and what is its purpose?

73. What are the Nazca lines?

74. What group painted the frescoes found at Bonampak, and what are they thought to represent?

75. In what current-day country in South America was Pre-Columbian art most highly developed?

76. Why was sacrifice so important to the Maya?

77. Name two Pre-Columbian cultures which are known for the high quality of their textiles:

78. What country practiced Shinto? Briefly describe it.

79A&B

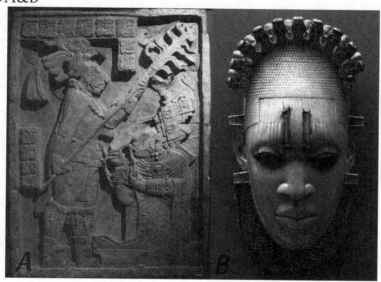

79. What culture is represented in the image shown in 79A?

80. Describe what you think is going on in the scene on 79A.

81. What culture is represented in the image shown in 79B?

82. Who is represented in the image shown in 79B?

83. What material is used for the image shown in 79B?

ANALYSIS OF UNKNOWN IMAGES

84. Identify the culture that produced the image below, and give the reasons for your attribution. Discuss the material that was used and describe the scene that is depicted.

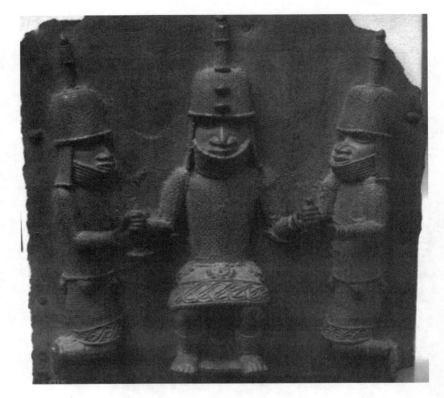

Culture:

Material:

Descrption:

Reasons:

85. What type of figures are depicted below? Attribute each to a culture and give the reasons for your attributions. What material was used to create them?

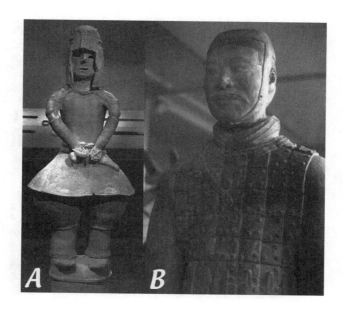

A. Type:

Material:

Reasons:

B. Type:

Material:

Reasons:

86. Compare the two women depicted below and attribute each to a culture. Give the reasons for your attributions and discuss the attitude toward women expressed by the figures.

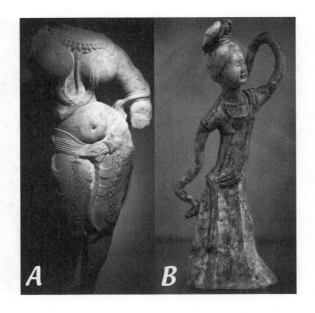

A. Culture:

 Reasons:

 Attitudes:

B. Culture:

 Reasons:

 Attitudes:

87. Attribute the vessel depicted below to a particular country and period and discuss the reasons for your attribution. What material was used and what was the purpose of such vessels.

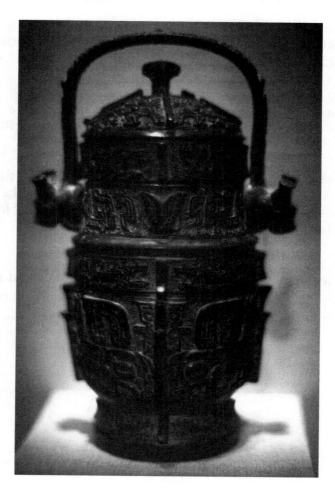

Country:

Period:

Material:

Purposes:

Reasons:

ESSAYS

Select one essay, and be sure and cite specific examples to illustrate your argument.

A. Compare a Chinese painting from the Song or Southern Song periods with a Japanese painting during the Kamakura period. What emotional mood is created in each and what stylistic devices does each artist use to create them?

B. Compare and contrast a pre-Columbian pyramid with a Buddhist stupa. How do they differ in appearance, construction and function.

C. The artists of the Shang period in ancient Chinese and those of the Benin kingdom in Africa were great bronze workers. Describe the stylistic characteristics and the types of objects that each created. How did their purposes differ?

D. Discuss the relationship between Egyptian, Roman and Khmer rulers and their gods and the way they used art to demonstrate that relationship. Select appropriate images to illustrate your discussion.

QUIZ ANSWERS
WORLD BEYOND EUROPE

MULTIPLE CHOICE

1. c 2. c 3. a 4. b 5. b 6. d 7. c 8. a 9. c 10. c 11. a 12. b
13. d 14. d 15. d 16. a 17. c 18. c 19. d 20. a 21. b 22. b 23. d 24. c
25. d 26. b 27. d 28. c 29. a 30. a 31. b 32. a 33. a 34. b 35. a 36. a
37. c 38. a 39. a 40. b 41. b 42. d 43. b 44. b 45. b 46. a 47. c 48. d

MATCHING

49. b 50. g 51. c 52. a 53. h 54. r 55. d 56. i 57. o 58. j 59. m
60. q 61. k 62. l 63. p

SHORT ANSWER QUESTIONS

64. Offerings for the dead, most often wine and cooking vessels.

65. The belief in an after-life for believers.

66. Confucius.

67. The Han and Tang dynasties often left funerary offerings of human figures as attendants for the dead, soldiers and horses.

68. A very early novel that describes court life and romance in ancient Japan.

69. Nok.

70. Portuguese.

71. Zimbabwe, Africa.

72. The kiva is a spiritual center for the community and a male council house. Private rituals took place there as well as preparations for public ceremonies.

73. They are huge drawings on the Nazca Plain in Peru some of animals others of geometric designs.

74. The Maya painted the frescos and they are thought to represent a ceremony welcoming a new heir to the throne, complete with sacrifices.

75. Peru.

76. The Maya believed in a reciprocal relationship between humans and the gods, and blood had to be provided if the gods were to survive.

77. The Paracas and the Wari.

78. Japan practiced the nature-based religion of Shinto which developed along with society. There are no formal scriptures and no founding figures.

79. Mayan

80. The kneeling Mayan queen is taking part in a bloodletting ritual.

81. Benin

82. The queen mother of the Oba is represented.

83. Ivory

ANALYSIS OF UNKNOWN IMAGES

In each of the answers to the identification questions, the first date given is the range within which you should have dated the work, and the second, in parenthesis, is the actual date accepted by scholars.

84. Benin, fifteenth to eighteenth centuries (*The King with Two Chiefs*, sixteenth to seventeenth centuries. Bronze, The British Museum, London.)

 The bronze panel showing the king flanked by two chiefs is very closely related to the Benin altar illustrated in the text. The figures are depicted with the same simplified, somewhat rigid naturalism; the helmeted heads, the decorated necks, and the bodies are all part of the same cylindrical form to which small arms and legs are attached. The patterns of armor, helmets, and necklaces further emphasize the rigidity of the forms and the hieratic dignity of the king. As in the Benin altar, the background is covered with engraved decoration; no surfaces except faces, hands, and feet are free from it. Like many Benin bronzes, this one glorifies the power of the divine king.

85. A. Japan, Kufan, first to sixth centuries (Haniwa figure of a warrior, Tumulus period, fifth century.)

B. China, Qin dynasty, third century B.C.E. (Soldier, Lintong, Shaanxi Province, China, 221-206 B.C.E.)

Figure A is an example of the *haniwa* figures that were produced in Japan during the Kufan period. It is molded in tubular form, with the legs and torso echoing the cylindrical shape of the base. The slit eyes, the necklace, and the swelling legs are very similar to those of the haniwa figure illustrated in the text. The forward motion of the arms seems to indicate that he is in the act of drawing his sword. As in other *haniwa* figures, the simple, direct forms of the warrior seem to express a type of energy and creativity that is specifically Japanese.

The Chinese warrior—stiff and formal, rigidly frontal, done with simple volumes and sharp, realistic details—shows all the stylistic characteristics of the warriors discovered in the tomb mound in Shaanxi, China. With his detailed armor, he represents one member of the vast army who made up the imperial bodyguard. The realistic style seems to be much more sophisticated than that of the energetic Japanese *haniwa* figure.

86. A. India, first century B.C.E. to 11th century C.E. (Torso of a Woman, 10th century. India. Musée Guimet, Paris.)

The sensuous and undulating curves of the Indian figure are reminiscent of those of the voluptuous women from the amorous couples from the later Vishvanatha Temple at Khajuraho. The exaggeration of the sexual characteristics, the rich jewelry, and flimsy veil all emphasize the eroticism that played a much greater role in Indian art than it did in the Chinese or Japanese traditions. Such figures in found throughout the Hindu tradition but not in the Moslem tradition of India.

87. China, Shang, sixteenth to eleventh centuries B.C.E. (Engraved bronze Yor-Win container. Washington D.C. Smithsonian Institution.) This bronze vessel is a typical example of the most outstanding type of art produced during the Shang period in China. It possesses the dynamic sculptural shape and rich surface decoration that is typical of such pieces. Although of a different shape and design, it bears a strong stylistic resemblance to the twelfth-century B.C.E. bronze *guang* illustrated in the text. Both pieces are a masterly blend of naturalistic and abstract forms; the strange zoomorphic creatures both sport horns that would belong neither to the creature represented in the text nor to the bird that forms the basis of this vessel. The silhouettes of both vessels are dynamic and broken, and in both cases the decoration seems to be an integral part of the sculptural whole rather than mere surface embellishment. The decoration of both vessels, and undoubtedly the shapes themselves, carried a symbolic meaning that was important to the ritual purpose of Shang bronzes.

ESSAYS
Answers found throughout the text.

TIP

The trefoil top is pieced together differently in this block and Pattern 57 (original blocks 145 and 156), perhaps to suit the size of fabric pieces in the coverlet maker's stash, as one set of seams doesn't appear technically better than the others from a construction viewpoint. If your fabrics aren't large enough to cut this big motif in one piece, you could adapt this idea.

Place on fold

Fig 2
Template (half of design)
Actual size of whole template
9in (22.9cm) square

Fold a 9in paper square in half and trace off the template, lining up along the fold as indicated. by the dashed line. Repeat the design for the other half by tracing, or carefully cut out the pattern through all the layers with the paper still folded. Draw balance marks across each seam line (see Techniques: Mosaic Patchwork: Papers and Tacking). The horizontal seams in the trefoil top are optional.

Two squares on point

Original patchwork blocks: 181, 182

Block size: 4½in x 2¼in (11.4cm x 5.7cm) finished

Original method: mosaic patchwork

Modern method: machine patchwork

Original Method

1 Cut out and tack (baste) all pieces.

2 Oversew the corner triangles to the squares.

3 Add the side triangles and sew together to make the block. Match balance lines throughout the block.

Fig 1

Template

Actual size 4½in x 2¼in (11.4cm x 5.7cm)

This is the whole block at full size. Draw balance marks across each seam line (see Techniques: Mosaic Patchwork).

Modern Method

1 Cut two 2in (5cm) squares and cut them in half diagonally for the corner triangles. Cut one 2½in (6.4cm) square and cut in half diagonally for the side triangles. Cut two 2³⁄₃₂in (5.3cm) squares for the centre – these are easier to cut by adding a ¼in (6mm) all round the square templates than to measure 2³⁄₃₂in.

2 Sew one side triangle to each square.

3 Sew each unit to the other and add the corner triangles last to finish the block.

References

(A History of the 1718 Coverlet)

[1] Baker, T., (1706), *Hampstead Heath*, A Comedy, London, Prologue; Barker, Mrs. J., (1723), A Patch-Work Screen for the Ladies, or, Love and Virtue Recommended, London, Introduction

[2] At a meeting in September 2003 quilt historians from the UK, France, Norway and the US, who had researched this technique, considered written input from colleagues in Australia and the Netherlands and discussed problems arising from the use of too many terms for this patchwork method and, in particular, the application of a term implying a limited geographical origin. It was recommended that the term mosaic patchwork technique would be more acceptable, applying to all patchwork constructed using fabric wrapped over paper templates, whether made from a single repeating shape or examples such as the 1718 Silk Patchwork Coverlet

[3] O'Connor, D. '*The Dress Show: A Study of the Fabrics in the 1718 Silk Patchwork Coverlet*', Quilt Studies, 4/5 (2002/3) p.79

[4] Swift, J. (1745), Directions to Servants in General, London, Chap. IX, p.81

[5] Old Bailey Proceedings Online, December 1726 trial of Mary Rich (t17261207-57), www.oldbaileyonline.org, accessed: 24 November 2008

[6] Thompson, K. and Halliwell, M., 'An Initial Exploration of the Benefits of Using Transmitted Visible Light and Infrared Photography to Access Information Concealed within Multi-layered Textiles', Scientific Analysis of Ancient and Historic Textiles', Postprints of the first annual conference of the AHRC Research Centre for Textile Conservation and Textile Studies, 13–15 July 2004, London: Archetype Publications, pp.177–184; Thompson, K. and Halliwell, M., 'Who Put the Text in Textiles? Deciphering text hidden within a 1718 coverlet: Documentation of papers hidden an early 18-century coverlet using transmitted light photography', in Hayward, M. and Kramer, E. edit. (2007), Textiles and Text: Re-establishing the Links Between Archival and Object-based Research, AHRC Research Centre for Textile Conservation and Textile Studies Third Annual Conference, 11–13 July 2006, London: Archetype Publications, pp.237–244; Long, B. 'Uncovering Hidden Marks on the 1718 Silk Patchwork Coverlet', Quilt Studies, Issue 9 (2008), pp.62–83

Bibliography and Further Reading

Quilt Studies: The Journal of the British Quilt Study Group Issue 9 (The Quilters' Guild of the British Isles, 2008)

It's All in the Making exhibition catalogue (The Quilters' Guild of the British Isles, 2013)

Quilt Treasures of Great-Britain-Heritage: The Heritage Search of The Quilters' Guild Janet Rae, Margaret Tucker, Dinah Travis and Pauline Adams (Feb 1996)

The Quilter's Bible Linda Clements, F&W Media International, 2011

About The Quilters' Guild

The Quilters' Guild of the British Isles is the national organization for people involved in patchwork, quilting and appliqué. Across the UK volunteers in eighteen regions organize activities such as talks, workshops and exhibitions for members and visitors. Volunteers work with Young Quilters to pass on sewing skills to a new generation. The Quilters' Guild Collection itself contains over 800 examples of patchwork, quilting and appliqué, which range in date from the early 18th century to contemporary 21st-century quilt art. The oldest initialled and dated piece of patchwork in the UK, the 1718 Silk Patchwork Coverlet, is part of The Quilters' Guild Collection. For more information see www.quiltersguild.org.uk and www.quiltmuseum.org.uk

Suppliers

United Kingdom

The Cotton Patch
1285 Stratford Road, Hall Green,
Birmingham, West Midlands B28 9AJ
Tel: 0121 7022840
www.cottonpatch.co.uk
Fabrics and other quilting supplies

The Silk Route
Cross Cottage, Cross Lane, Frimley
Green, Surrey GU16 6LN
Tel: 01252 835781
www.thesilkroute.co.uk
Silk fabric specialists

Oakshott and Company Ltd
19 Bamel Way, Gloucester Business
Park, Brockworth, Gloucester GL3 4BH
Tel: 01452 371571
www.oakshottfabrics.com
Shot cotton specialists

Art Van Go
The Studios, 1 Stevenage Road,
Knebworth, Hertfordshire SG3 6AN
Tel: 01438 814946
www.artvango.co.uk
Procion dyes and fabric paints

America

eQuilter.com
5455 Spine Road, Suite E, Boulder, CO 80301
Tel: USA Toll Free: 877-FABRIC-3 or:
303-527-0856
www.eQuilter.com
Fabrics and quilting supplies (mail order)

Hancock's of Paducah
3841 Hinkleville, Paducah, KY, USA 42001
Tel: domestic: U.S. 1-800-845-8723
International: 1-270-443-4410
www.hancocks-paducah.com
Fabrics and quilting supplies

Acknowledgments

I would like to thank the following for contributions into this project. Liz Whitehouse (Chief Executive), Christine Morton (Operations Manager), Heather Audin (Curator) and all the staff at The Quilters' Guild of the British Isles who made this book possible. Bridget Long for research into the history of the coverlet. Pauline Adams and Tina Fenwick Smith for organizing the replica coverlet project and for advice on the techniques used. All of The Quilters' Guild members who made the replica coverlet. Val Shields and Judith Dursley, who supported the idea of a 1718 book. Maureen Poole for making the Cantata wall hanging at very short notice. Jeremy Phillips for his excellent photographs of the coverlet.

Many thanks to my husband Glyn, who has had to 'live' with the project for many months. Thanks to the team at David & Charles for turning my work into another beautiful book. Finally, the biggest thanks should go to someone who is, for now, anonymous – the maker of the original 1718 coverlet.

About the Author

Susan Briscoe writes and designs for patchwork and quilting magazines and teaches patchwork and sashiko quilting in the UK and overseas. A graduate of UCW Aberystwyth, she began quilting after working as an Assistant English Teacher on the JET (Japan Exchange Teaching) programme in Yuza-machi, Yamagata Prefecture, Japan, in the early 1990s. Although she specializes in Japanese textile themes, she is also passionate about Britain's quilting heritage. She has written over ten books on quilting, including three books on patchwork bags and two books on Japanese sashiko. Susan lives in Scotland, UK.

© The Quilters' Guild. Photography by Catherine Candlin.

Index

A DAVID & CHARLES BOOK
© F&W Media International, Ltd 2014

David & Charles is an imprint of F&W Media International, Ltd
Pynes Hill Court, Pynes Hill, Exeter, EX2 5AZ, UK

F&W Media International, Ltd is a subsidiary of F+W Media, Inc
10151 Carver Road, Suite #200, Blue Ash, OH 45242, USA

Text © Susan Briscoe 2014
Layout, techniques photos pages 34-45, quilt pg 34 & 44 © F&W Media International, Ltd 2014
Photographs of quilts © The Quilters' Guild 2014. Photography by Jeremy Phillips – except those individually
copyrighted on the page.
Diagrams on pages 37 & 38 © Pauline Adams.
Technique photos plus quilts on pages 34 & 44 photographed by Ally Stuart

First published in the UK and USA in 2014

Susan Briscoe has asserted her right to be identified as author of this work in
accordance with the Copyright, Designs and Patents Act, 1988.

The author and publisher have made every effort to ensure that all the instructions in
the book are accurate and safe, and therefore cannot accept liability for any resulting
injury, damage or loss to persons or property, however it may arise.

Names of manufacturers and product ranges are provided for the information
of readers, with no intention to infringe copyright or trademarks.

A catalogue record for this book is available from the British Library.

ISBN-13: 978-1-4463-0443-3 hardback
ISBN-10: 1-4463-0443-7 hardback

ISBN-13: 978-1-4463-0444-0 paperback
ISBN-10: 1-4463-0444-2 paperback

Printed in China by RR Donnelley for:
F&W Media International, Ltd
Pynes Hill Court, Pynes Hill, Exeter, EX2 5AZ, UK

10 9 8 7 6 5 4 3

Acquisitions Editor: Sarah Callard
Editor: Matthew Hutchinson
Project Editor: Lin Clements
Senior Designer: Victoria Marks
Production Manager: Kelly Smith

F+W Media publishes high quality books on a wide range of subjects.
For more great book ideas visit: www.sewandso.co.uk